CUNARD

THE MOST FAMOUS OCEAN LINERS IN THE WORLD™

LUCIAN
FREUD

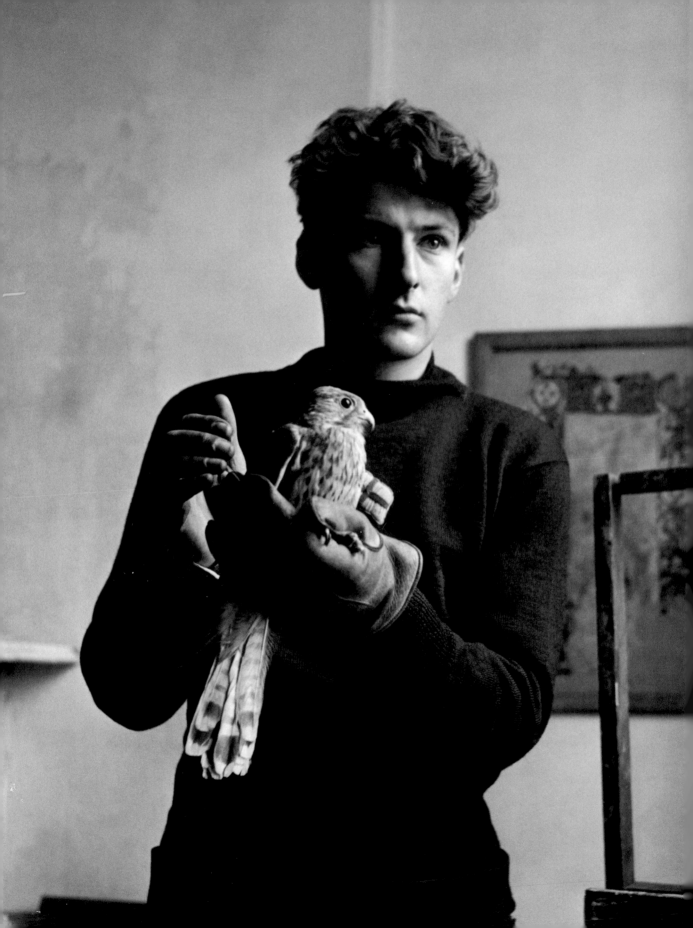

LUCIAN FREUD

BRITISH ARTISTS

VIRGINIA BUTTON

TATE PUBLISHING

First published 2015 by order of the Tate Trustees
by Tate Publishing, a division of Tate Enterprises Ltd,
Millbank, London SW1P 4RG
www.tate.org.uk/publishing

For George and Brenda

A catalogue record for this book is available from the British Library
ISBN 978 1 84976 314 1

Distributed in the United States and Canada by ABRAMS, New York
Library of Congress control number applied for

Designed by Webb & Webb
Colour reproduction by DL Imaging Ltd, London
Printed in Hong Kong by Great Wall Printing Company Ltd

Front cover: *Girl with a Kitten* 1947 (detail of fig.9)
Frontispiece: Clifford Coffin, *Lucian Freud* 1947
p.6: *Portrait of Rose* 1978–9 (detail of fig.37)

Measurements are given in centimetres, height before width.

CONTENTS

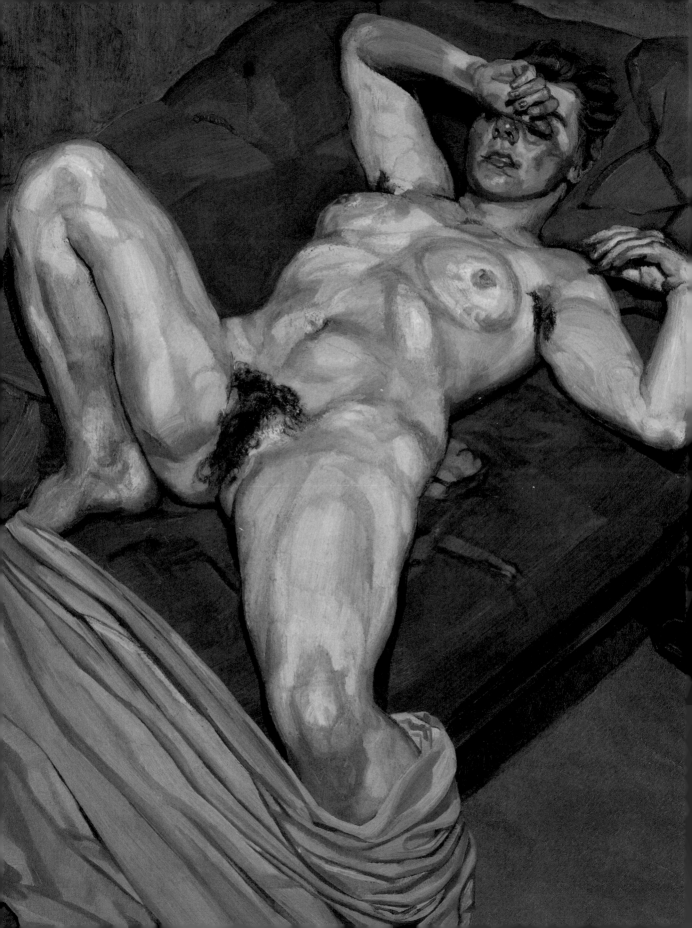

1 INTRODUCTION

SHOCKED, REPELLED, SEDUCED – few have remained
indifferent to Lucian Freud's shameless images of the human subject.
Building on the nineteenth-century European tradition of the non-idealised
nude, Freud was able with his 'naked portraits', as he called them, to
reinvent portraiture. Critics have celebrated his ability to suggest the
visceral, psychological and emotional experience of what it means to inhabit
a finite, human body. More recently, Freud's complex relationship to the
history of art, to a pantheon of old masters – mostly of northern European
tradition – has become more apparent. His ambition was to create for the
present the life-enhancing experience of seeing the world through painting.

Despite his growing international reputation and wider popularity from
the 1980s, Freud's attachment to realism, and particularly to the human
figure, was not always well received. He emerged in the 1940s in a period
of turbulence and uncertainty when huge demands were made of art and
artists, socially, politically and morally. Leading up to the Second World
War and during its aftermath, the role of art and the ideological significance
of culture were passionately debated. Modern artists were under pressure
to take sides, to sign up to manifestos, to be responsible and socially
relevant. Consistently contrarian, Freud's position, like that of a number of
other artists, was to resist what he perceived as fashion or the co-option of
art in the service of agendas. He wanted to produce images that could speak
outside of time, which for him meant investing in the medium of paint as
opposed to photography, film or more recent digital media. This position

was of course in itself informed by an ideological view based on the liberal idea of the individual and the transcendent power of art.

Freud's aim to 'make the paint work as flesh' evolved in the 1950s, when asserting the human subject seemed the most appropriate response to the atrocities of war and threat of human extinction. By the 1960s Freud and other figurative painters associated with the 'School of London' – with the exception of Francis Bacon (1909–1992) – were considered talented but more or less passé, superseded by abstract expressionism and other progressive forms of practice.[1] Later, in the 1980s and 1990s, a renewed interest in painting and the human subject gave their work a new significance. Now, perhaps more than ever, the accentuated naturalism of Freud's naked portraits continues to capture attention. As intimate documents of human exchange they defy our increasingly hyper-mediated, artificialised culture.

Freud limited his subjects to the seemingly mundane – the figure from life, people, animals and things he knew and loved, the particular interior space of the studio and its margins. These limitations enabled him to explore and connect with big themes, such as perception, human subjectivity, time and mortality, and in particular the idea of the body as carrier or index of personality or individuality. These themes shifted in and out of critical and cultural focus during his lifetime. Although he declared his approach to be intuitive, instinctive and factual, the questions that interested him were nonetheless deeply philosophical. Ultimately, Freud's concern was to explore the limits of how one human being might 'know' another, and how this 'knowing' might be revealed tangibly in paint.

Slipping in and out of the limelight, first as the fêted 'boy wonder' in the 1930s and 1940s, then as the edgy outsider and womaniser gambling in Soho with Bacon in the 1960s, Freud emerged triumphant as an internationally acclaimed realist painter and grand old man of British art. He projected an image of the artist that has been difficult to resist. In the mould of art-historical greats such as Titian (1485–1576) and Rembrandt (1606–1669) he continued painting vigorously in old age, achieving his desire never to retire but 'to paint myself to death'.[2]

Critics have speculated about his apparent amorality, and the influence of this on the meaning of his work. Was he an egocentric misogynist, a visual devourer of female flesh, or a compassionate truth teller about

the human condition who valued and celebrated all living things? Freud's self-confessed attention to his subjects – a working method involving intense and prolonged observation – has been routinely described by critics in cold, clinical terms ('dissection', 'forensic', 'specimen'), while his gaze ('remorseless eye', 'unblinking stare') has been mythologised as hypnotic power.[3] Inevitable comparisons have been drawn between Lucian and his grandfather Sigmund Freud (1856–1939), the founder of psychoanalysis, particularly between the analyst's iconic couch and that used by the painter. Both couches symbolise an interrogative process that strips away all pretence and social façade to expose darkest, innermost secrets. Freud's insistence on an intuitive creative process involving a kind of alchemy between artist and model – based on an essentialist belief in the individual and the artist as an especially creative type of individual – has made some critics question the validity of his project. Yet Freud's myth of the self continues to offer comfort in the face of current theories of its disintegration.

Freud was part of the establishment yet he jealously guarded his liberty to operate on the fringes. Turning his foreignness to an advantage in twentieth-century class-ridden England, he moved effortlessly between social strata, respected equally by literati, aristocracy and London's low-life, while remaining a detached observer, like Baudelaire's *flâneur*.[4] He became known for his lack of boundaries in all aspects of his life and work. Summed up by Marina Warner as 'a defining anti-hero of our own *fin de siècle*', Freud lived an enacted biography of the bohemian artist, apparently set against all social constraints and responsibilities, resisting any social ties – to wives, children, lovers – that might detract from his artistic ambition and purpose.[5] While this kind of bohemianism was not uncommon for artists of earlier generations, it exacerbated feminist objections to his work in the 1980s and 1990s.

Freud recognised the importance of advocates who could position his work, particularly within a narrative of the canon of western art. In the early years he rarely spoke about his work directly, with the notable exception of 'Some Thoughts on Painting', published in *Encounter* in July 1954.[6] From the mid-1990s he communicated across a range of media. While there are numerous publications on Freud – many of which were written in close collaboration with the artist – this book presents an opportunity to consider his life and work from a more distanced perspective as well as to reflect on his achievement in terms of legacy.

1

Loch Ness from

Drumnadrochit

1943

Pen and ink

39.7 × 45.4

Private collection

10

2 COMMITMENT TO LOOKING (EARLY YEARS TO 1951)

The subject must be kept under closest observation: if this is done, day and night, the subject – he, she or it – will eventually reveal the all without which selection itself is not possible.[1]

IN THE 1980S a number of high-profile exhibitions introduced Freud to new audiences, understandably emphasising his more recent work. For example, his British Council show of 1987–8 (Washington's Hirshhorn Museum, touring to the Musée National d'Art Moderne, Paris, Hayward Gallery, London, and the Neue Nationalgalerie, Berlin) included one hundred exhibits of which only ten were from the period 1940 to 1951. Since then scholars and curators have reviewed Freud's early years, establishing greater continuity between the disparate early works and his later, mature output. This chapter considers Freud's formative period, focusing on the development of his desire to look, scrutinise and record.

As an emerging artist, Freud preferred the medium of drawing, his style predominantly linear, even when painting (fig.1). This natural inclination was no doubt reinforced by the prevailing neo-romantic aesthetic of the war years, which, looking back to earlier centuries – from the twelfth-century Winchester Bible to William Blake (1757–1827) and Samuel Palmer (1805–1881) – celebrated linearity as intrinsically British. Besides, drawing was also more sustainable during a decade deprived of most basic materials. By the end of the 1940s, Freud astounded critics with a series of arresting portraits of his first wife, Kitty Garman (1926–2011), daughter of

Kathleen Garman (1901–1979) and the controversial British sculptor Jacob Epstein (1880–1959), before turning his back on his tense, linear style.

Born in Berlin in 1922, Freud was the second son of architect and former artist Ernst Freud (1892–1970). Named after his mother Lucie (1896–1989), he enjoyed a happy family life in an affluent part of the city, with holidays on the Baltic, or at his maternal grandfather's estate near Potsdam, and developed a passion for horses. Shortly after Hitler gained power in 1933, Freud moved with his family to London in the first wave of Jewish émigrés escaping the Nazi regime. Ernst was the youngest son of the renowned founder of psychoanalysis, Sigmund Freud, who in 1938 also fled Vienna, spending the last year of his life in London. Lucian had known his grandfather previously, and by all accounts they got on very well. They shared a love of Wilhelm Busch's comic strip *Max and Moritz* and Sigmund had encouraged his interest in drawing, giving him prints by Breughel. While Lucian downplayed his Jewish identity, the migration of the Freud family and later revelations of the horrifying extent of the holocaust must have affected his desire to embrace life on his own terms. It remains shocking that four of Sigmund Freud's sisters, all in their eighties, perished in Auschwitz and Treblinka. The Freud family were treated kindly in

2
The Refugees
1941
Oil paint on board
50.8 × 61
Private collection

3
Hospital Ward
1941
Oil paint on panel
25.4 × 35.5
The Duchess of Devonshire

England, and Lucian developed a deep affection for his new country, rarely leaving London after the 1970s.

On arrival, he boarded at a succession of schools, first Dartington Hall in Devon, then Dane Court and Bryanston in Dorset. Dartington and Bryanston were both progressive schools, giving Lucian licence to develop a 'wild child' reputation. At Dartington, for example, he often slept in the stables with the horses. At Bryanston he carved a horse in sandstone, one of his only sculptures, which gained him entry to the Central School of Arts and Crafts in London. As an habitué of the city's bohemian hot spots, notably the Café Royale and Coffee An', the teenage Freud captivated London's cultural and social élite. After only one term at Central, he enrolled at the East Anglian School of Painting and Drawing, in Dedham, Essex, privately run by the painters Cedric Morris (1856–1939) and Arthur Lett-Haines (1894–1978), who offered a more informal art education. Cedric Morris's sincere, robust paint work and emphasis on individuality rather than stylistic training had a considerable influence on Freud's early development, as evidenced by *The Refugees* 1941–2 with its frontal composition, naive style and dense, flattening application of paint (fig.2). Arguably, Morris's approach to portraiture had more influence on Freud than the Neue Sachlichkeit (New Objectivity) painters such as Christian

Schad (1894–1982), who emerged in Germany in the 1920s when Freud was still a child, and who were perhaps erroneously identified by critics in the 1940s and 1950s as sources for Freud's early, unforgiving portraits.[2]

Later Freud claimed that impulse was at the root of everything he did, both in art and life. In 1941 he went to Liverpool and, apparently seeking adventure, signed up as an Ordinary Seaman on a Merchant Navy ship. He voyaged across the Atlantic and back, was subjected to enemy attack and fell ill with tonsillitis. Returning months later, he was discharged and had his tonsils removed, an experience referenced in *Hospital Ward* 1941 (fig.3), substituting for himself his patron, the art collector and owner of *Horizon* magazine Peter Watson (1908–1956). In London Freud became friends with poets such as Stephen Spender (1909–1995) and was supported by Watson and other key players including *Horizon*'s editor, Cyril Connolly (1903–1974), who in 1940 published a *Self-Portrait* drawing by Freud, then only eighteen years old. Influential throughout the 1940s, *Horizon* set the cultural agenda, promoting young British writers and artists while maintaining an international literary and cultural perspective during an otherwise intensely insular and nationalistic period. Watson's affiliation with the pre-war international art world was important to Freud, enabling post-war introductions to such giants as Pablo Picasso (1881–1973) and Alberto Giacometti (1901–1966). Watson also nurtured the careers of both Freud and his friend John Craxton (1922–2009) by providing them with a studio in St John's Wood in 1942.

Freud's adolescent dandyism, anarchic exhibitionism and the intrigue fuelled by his family pedigree rendered him irresistible. According to artist and writer Lawrence Gowing (1918–1991) in his seminal monograph of 1982, 'People … recognized his force immediately; fly, perceptive, lithe, with a hint of menace.'[3] He became a news story, the *London Evening Standard* noting for example that, still in his teens, Freud 'promises to be a remarkable painter … intelligent and imaginative, with an instinctive rather than a scientific psychological sense'.[4] More importantly, Freud's talent was recognised by the cultural élite, including Kenneth Clark (1903–1983), collector, patron and influential young director of the National Gallery (1933–46), who contributed to the success of neo-romanticism at this time. During the early 1940s leading neo-romantic artist Graham Sutherland (1903–1980) became one of his mentors. Along with a number of young male artists, including Craxton and John Minton (1917–1957), Freud was briefly perceived as a neo-romantic, enthralled by the romantic northern tradition of art and influenced by Sutherland.

4
The Painter's Room
1943
Oil paint on canvas
62.2 × 76.2
Private collection

5
Lucian Freud, c.1943
Photograph by
Ian Gibson Smith

6
Dead Heron
1945
Oil paint on canvas
49 × 74
Private collection

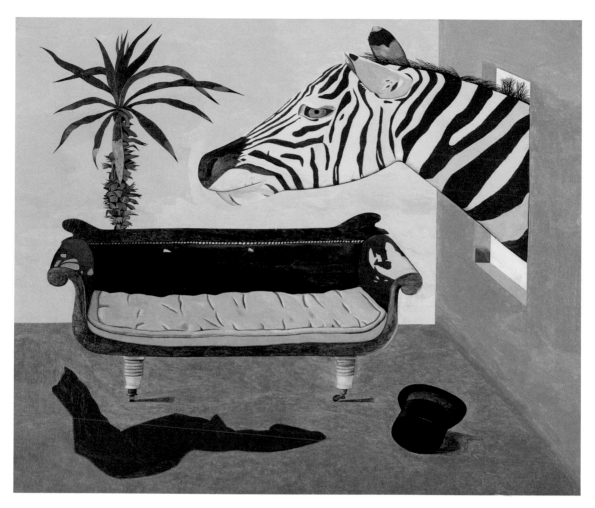

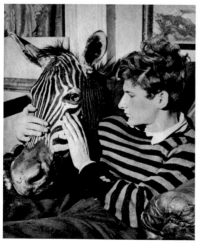

But Freud was also experimenting with other approaches including surrealism, which had been heavily promoted in England in the mid-1930s as the dominant international art movement in opposition to abstraction. Freud knew the work of such artists as Joan Miró (1893–1983), Salvador Dalí (1904–1989) and Giorgio de Chirico (1888–1978) first hand. His most resolved surrealist-type picture, and then largest work, was *The Painter's Room* 1943–4 (fig.4). Drawing on Miró's *Carnaval d'Arlequin* 1924–5 (Albright-Knox Art Gallery, Buffalo NY), it juxtaposes incongruous objects including a disproportionately large zebra's head, an anthropomorphic sofa, a spiky plant and discarded cloak and hat. It has been suggested that Freud deliberately referenced his grandfather's *Interpretation of Dreams* (1899), and he might well have enjoyed this association.[5] However, the picture was based on his new studio at Delamere Terrace, W12, and featured a real zebra's head, a gift from Lorna Wishart (1911–2000), who became his first serious love obsession. Freud was photographed in a striped sweater caressing the zebra head, perhaps emulating the self-mythologising posturing of surrealists such as Dalí. But profiling his equine features, the image also alludes to his affinity with horses and interest in animal instinct (fig.5). Later, fiercely opposed to mannerism or stylistic affectation, Freud commented on surrealism's theatricality: 'I think Lautreamont's umbrella and sewing machine on an operating table was an unnecessarily elaborate encounter. What could be more surreal than a nose between two eyes?'[6] While rejecting surrealism as a singular approach, Freud nevertheless remained interested in the invisible realities of the unconscious and instinct as elements of his naturalism.

Freud might also have seen the enigmatic *Zebra and Parachute* 1930 (Tate) by Christopher Wood (1901–1930) and been aware of Wood's tragic demise, following his early promise as England's talented figurative painter in the 1920s. The cult of the doomed, beautiful youth loomed large in the 1930s and 1940s, the loss of an entire generation of 'golden lads' in the Great War sharpening the desire of cultural guardians such as Clark and Watson to protect and promote emerging talent. As a Rimbaud-like 'magnetic adolescent', Freud benefited from early attention, although he felt increasingly controlled and limited by the weight of expectation.[7]

While Freud's subject matter was varied, it was often inspired by images that had disturbed him, such as paintings of dead creatures by Chaim Soutine (1893–1943) or the visceral, putrefying flesh of the Isenheim Christ by Matthias Grünewald (1470–1528). But dead things – plants, fruit, dead animals and birds – also provided a starting point for still-life drawings and paintings that allowed

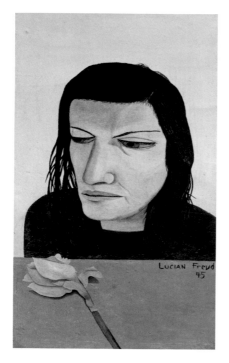

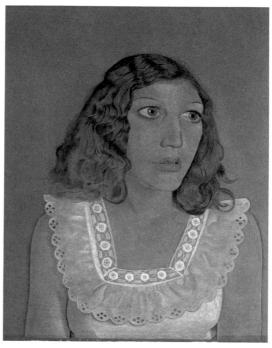

7

Woman with a Daffodil

1945

Oil paint on board on canvas

23.8 × 14.3

Museum of Modern Art,

New York. Purchase, 1953

8

Girl in a White Dress

1947

57 × 48

Conte, crayon and

pastel on buff paper

Mrs Pamela Wynn

him to concentrate fully on their depiction (fig.6). In 1942, on seeing Freud's drawing of poet Nicholas Moore's dead baby (later published in *Horizon*), Sutherland encouraged him to take life classes at Goldsmith's College in London, which further instilled a discipline of looking that became the foundation of his way of working. Then in 1945 he produced two small head and shoulder portraits of a woman with exaggerated eyes, *Woman with a Tulip* (private collection) and *Woman with a Daffodil* (fig.7). The sitter was Lorna Wishart, the paintings an attempt to convey the strong feelings he had for her. The affair was destructive and at an end, but Freud had discovered what would become his main preoccupation, namely painting people and things that mattered to him. It was as if by looking, he could really know the thing observed, an impetus later described by Gowing as 'a fantasy of visual possession'.[8]

David Alan Mellor has noted that a 'romance of and with the eye' has been key to Freud's work – from his initial fascination with the eye as a motif, strongly suggesting a desire to represent an individual's state of mind or inner life – to a more general emphasis on clarity of vision. The eye was prevalent in surrealist imagery but Freud was also preoccupied with the German and Flemish traditions of optical clarity.[9] By the early 1930s the concept of the 'optical unconscious', postulated by the German writer and philosopher

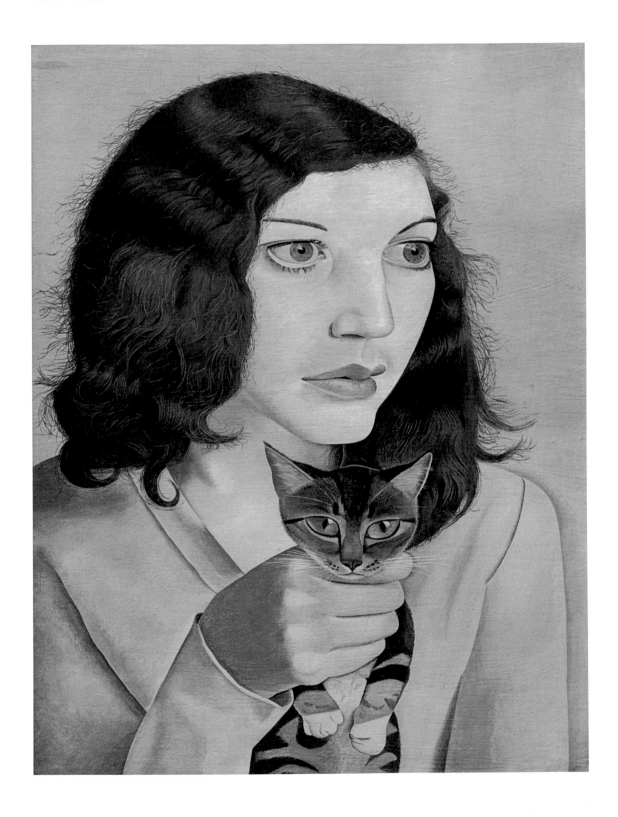

Walter Benjamin (1892–1940), identified the power of the photographic lens to reveal realities previously invisible to the naked eye, just as psychoanalysis was discovering the instinctual unconscious. Entirely new structures of matter would be brought to light by the close-up and slow motion in cinema.[10] Achieved with pliable sable brushes, Freud's spellbinding, painstakingly applied marks obsessively suggest such minute details as hair, eyelashes, reflections in irises and the inner rim of the eye. This approach was readily compared with the hyper-observed images of early Netherlandish masters such as Jan van Eyck (1395–1441), Rogier van der Weyden (1400–1464) or Hans Memling (1430–1494), while his acute attention to texture – hair, feathers, leaves, lace (fig.8) – was most probably influenced by German artist Albrecht Dürer (1471–1528).[11] Freud's recurring ocular motif and meticulous vision seem to challenge the overwhelming authority of the camera lens at this time in favour of the human eye, establishing his ongoing mistrust of the camera as a purveyor of truth.

Freud's looking and recording through a process of extreme concentration culminated in a series of memorable portraits of his first wife, Kitty (Lorna's niece). They met in February 1947, married in 1948 and divorced in 1952. Limiting his subject and compositional format, he depicted Kitty in close-up, anxious, vulnerable, poised on the edge of crisis. In *Girl with a Kitten* 1947 ivory-skinned and wide-eyed Kitty gazes intently out of the picture, clutching a kitten by the scruff of the neck and seemingly almost choking it (fig.9). It is tempting to speculate on the pun between Kitty and the 'kitty' in her grasp. She found the proximity of his gaze as he sat observing her every pore hard to endure. These works are as much representations of being seen as seeing, the intensity of Freud's observation compelling the viewer to see the sitter's discomfort through his eyes.[12]

9
Girl with a Kitten
1947
Oil paint on canvas
39.5 × 29.5
Tate. Bequeathed by
Simon Sainsbury 2006,
accessioned 2008

Critics read these anachronistically styled images, with their early Netherlandish enamel-like surfaces and optical intensity, as Freud's response to the mid-century crisis in the human condition. His bleak outlook, responsive to the aftermath of war, seemed to reflect an existentialist philosophy emanating from Paris, and prefigured by the writing of Franz Kafka (1883–1924), whom Freud admired. At this time Freud illustrated William Samson's novel *The Equilibriad* (1948), a story emphasising the instability of the body that drew heavily on Kafka and other literary expressions of the fragility and absurdity of human life. Writing in 1950, critic David Sylvester (1924–2001) observed that Freud seemed to have 'hypnotised the subject, so that under his stare it reveals its innermost secret … His creations inhabit a world in which the process of existence has been slowed down

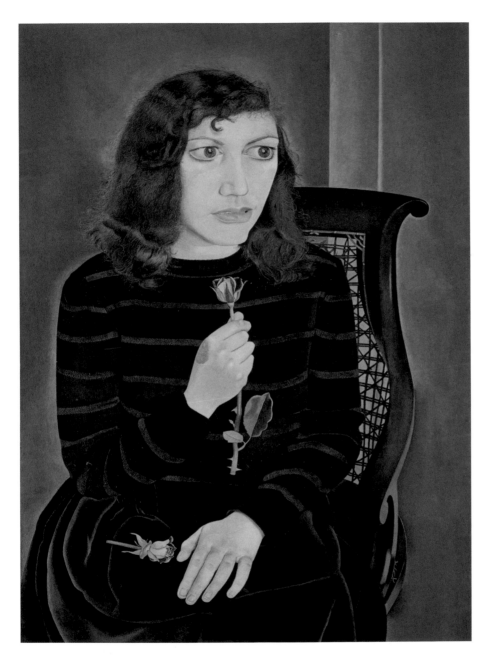

10
Girl with Roses
1947–8
Oil paint on canvas
106 × 75.6
British Council, London

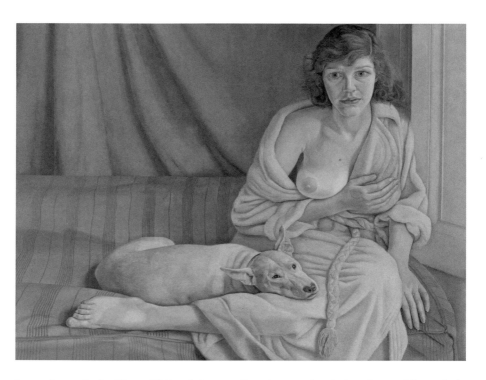

11
Girl with a White Dog
1950–1
Oil paint on canvas
76.2 × 101.6
Tate. Purchased 1952

into a hysterical stillness.'[13] For Sylvester, Freud seemed to bring the world to a halt in order to stop horrific events happening, such as the strangulation of a kitten.

Newly pregnant with their first child Annie, Kitty sat for *Girl with Roses* 1947–8, which casts her as a modern Madonna of the Annunciation, holding a thorny rose in place of a lily (fig.10). Older British artists, such as Sutherland and Henry Moore (1898–1986) in his *Madonna and Child* 1943–4 (St Matthew's Church, Northampton) were also reworking traditional Christian imagery. During the 1940s connecting to tradition and the past seemed vital to many British artists. The threat that fascism posed to national culture was highlighted by Kenneth Clark's removal of the treasures of the National Gallery from Trafalgar Square to the protection of a Welsh mine for the duration of the war. After the war, artists in Europe and America sought new forms of expression. Freud's position, like that of prominent artists such as Giacometti, Bacon and Andrew Wyeth (1917–2009), was to adopt a modernist realism that rejected innovation and novelty as an inevitable process, preferring to ground his work in the material world, building on tradition rather than discarding it.

The shabby aesthetic of Freud's *Girl with a White Dog* 1950–1, with its enclosed space and drab furnishings, registered an existential mood (fig.11).

12
Interior in Paddington
1951
Oil paint on canvas
152.4 × 114.3
Walker Art Gallery,
National Museums and
Galleries on Merseyside

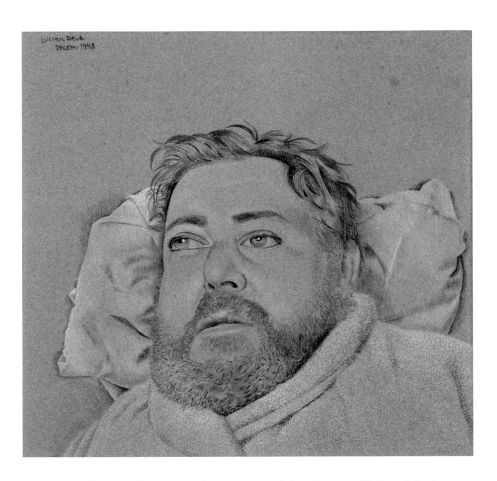

13
Christian Bérard
1948
Black and white conté
crayon on paper
41 × 44
Private collection

Freud's striking combination of intimacy and detachment distinguished his work from the similarly revealing and more erotically charged pre-war images that the British artist Stanley Spencer (1891–1959) painted of his wife. The partially disrobed figure with canine companion prefigures Freud's later 'naked portraits' and fascination with the fundamentally animal nature of human beings. This was Freud's last picture of Kitty, who seems more accepting of her role, perhaps because she knew it was nearing an end. The prominent symbols of fidelity – wedding ring, bull terrier nestled into her thigh – belie the breakdown of the marriage. In 1950, through one of his sitters – Ann, Vicountess Rothermere – Freud met an intoxicating muse in Lady Caroline Blackwood (1931–1996), daughter of the 4th Marquess of Dufferin and Ava, finally persuading her to elope with him to Paris in 1952.

In 1951 a cluster of works, including the portraits of Kitty, *Interior in Paddington* 1951 (fig.12) – Freud's portrait of Harry Diamond (which won

a prize at the Festival of Britain) – and the Dürer-like drawing of artist and stage designer Christian Bérard (1902–1949), executed in 1948 just before his untimely death (fig.13), convinced critic Herbert Read (1893–1968) that Freud was 'the Ingres of Existentialism'.[14] Read's label remains pertinent both in terms of Freud's characteristic precision, a skill he admired in the work of French artist Jean-Auguste-Dominique Ingres (1780–1867), and as a description of his insistence on the frailty of the body. As Mellor suggests: 'Animal and human bodies in Freud's universe are inscribed with mortality … each bearing the anti-Romantic, Naturalistic marks of a post-Darwinian world of extinctions and vertiginous existence.'[15]

When the war ended, Freud – along with many artists – was keen to travel. A visit to Paris in summer 1946 began a decade-long liaison with the Paris-based avant-garde. As William Feaver has noted, *Interior in Paddington* is a London painting with a Parisian feel, drawing on the French miserablism of Francis Grüber (1912–1948), as well as *The Painter and his Model* 1917 (Musée National d'Art Moderne, Centre Pompidou, Paris) by Henri Matisse (1869–1954).[16] In 1946 he met Picasso, but it seems that Giacometti made a more lasting impression on him and other British figurative realist artists later identified as the School of London. Freud was a frequent visitor to the Swiss sculptor's studio, obliging him as a sitter. He admired Giacometti's integrity, his complete commitment to the life of the studio and the human subject, and in particular his attempt to render the human condition by phenomenological means – by looking, feeling and registering the body in space. Unlike Picasso, Giacometti spurned celebrity and the increasingly public post-war trappings of art-stardom.

By the end of his twenties Freud realised that his independence as an artist was paramount, as Lawrence Gowing later reported: 'For him painting has to be, among other things, the collection of objects that he likes, the realising of data that he values, an accumulation of what he enjoys or desires – it amounts to the same.'[17] While he was established as a realist, Freud's belief in individual specificity was perhaps the legacy of neo-romanticism's insistence on the primacy of individual creativity as the only ideology that could defend culture against collective extremism. In the mid-1940s Sutherland introduced him to rising star Francis Bacon, sparking a friendship that would encourage him in the 1950s to radically transform his working practice and embrace paint as his primary medium. In 1950 David Sylvester announced that Freud had superseded Dylan Thomas as *the* legendary figure of the younger generation.[18] Already, the mythology that surrounds the painter had begun to accrete.

3 COMMITMENT TO PAINTING (1952 TO MID-1960s)

A painter's relationship with the paint is the most important artistic relationship there is – on a par with behaviour in life.[1]

WHEN I THINK OF THE WORK of Lucian Freud, I think of Lucian's attention to his subject. If his concentration were to falter he would come off the tightrope; he has no safety net of manner. Whenever his way of working threatens to become a style, he puts it aside like a blunted pencil and finds a procedure more suited to his needs.[2]

The radical transition of Freud's approach to painting during the 1950s and early 1960s has been well documented. In 2005 he recalled the discomfort of his early close-focus method of working:

> I felt that the only way I could work properly was using absolute maximum observation and maximum concentration. I thought that by staring at my subject matter and examining it closely I could get something from it … I had a lot of eye trouble, terrible headaches because of the strain of painting so close.[3]

Clearly, the physical demands of his working method were unsustainable. This was addressed practically by standing to paint and, in 1958, by exchanging fine sable brushes for coarse hog's hair. The last work he made seated was *Hotel Bedroom* 1954, an edgy double portrait with Caroline in Paris (fig.14).

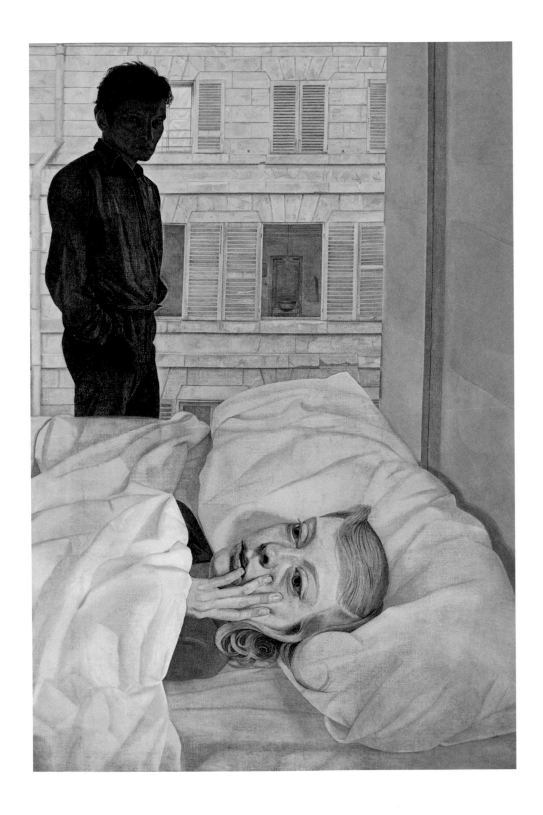

But what motivated his rejection of a way of working that had established him as a leading artist of his generation? This chapter considers Freud's growing identity as a painter in the European realist tradition in the decade following the war when realism and abstraction were competing for international recognition. With his close friend Francis Bacon he was supported by the young art critic David Sylvester, who championed modernist realism as an uncompromisingly contemporary vision of humanity connected to a rich and continuing tradition.[4]

Freud met Bacon (thirteen years his senior) in 1945, the year in which Bacon's *Three Studies for the Base of a Crucifixion* (Tate) positioned him as the most exciting painter in England and likely heir to Picasso. Freud looked to Bacon for stimulus until their friendship ended in the late 1970s. By 1950 Freud had largely given up drawing. Bacon's impact on his commitment to painting was significant, as were the older artist's rapacious appetite for art and life. As Freud recalled:

> His work impressed me, his personality affected me. It was through that and talking to him a lot. He talked a great deal about the paint itself carrying the form, and imbuing the paint with this sort of life. He talked about packing a lot of things into one single brushstroke, which amused and excited me, and I realised that it was a million miles away from anything I could ever do. The idea of paint having that power was something which made me feel I ought to get to know it in a different way that wasn't subservient. I mean, I used to make it always do the same things for me: I felt I'd got a method which was acceptable and that I was getting approval for something which wasn't of great account. Though I'm not very introspective I think that all this had an emotional basis. It was to do with questioning myself as a result of the way my life was going. I felt more discontented than daring. I didn't want my work to lean on anyone in particular. I wanted it to be true to me, and I had an idea that however much I might go to the National Gallery and look at the art I really like, what I must learn from the pictures was a way of dealing with things, with paint and subject-matter, rather than a manner in which to work.[5]

14
Hotel Bedroom
1954
Oil paint on canvas
91.1 × 61
Beaverbrook Art Gallery
(Gift of The Beaverbrook
Foundation), Fredericton
NB, Canada

Erudite, quick witted and charming, Bacon was intoxicating company. Both artists revelled in Bohemian excesses – gambling, nightclubbing and the thrill of sexual conquests. While they differed in many ways – notably Bacon worked from photographs and Freud was committed to working from life – Bacon's dark and extreme vision of the human subject, achieved through

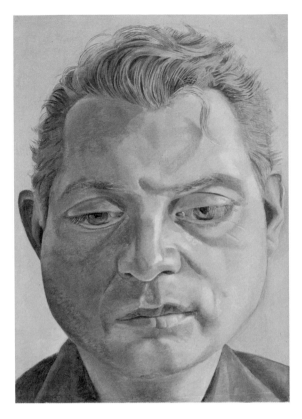
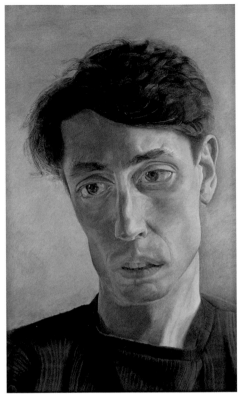

volatile risk-taking with paint, excited Freud, as did his ability to exploit the visceral properties of oil paint to suggest carnality and human presence.

Bacon painted Freud first in 1951, and a year later Freud produced a modestly scaled but memorable portrait of his friend, intended to hang in Wheeler's fish restaurant where Bacon dined daily (fig.15). Critics admired Freud's insight; as Robert Hughes later commented: 'Bacon's pear-shaped face has the silent intensity of a grenade in the millisecond before it goes off.'[6] Purchased almost immediately by the Tate Gallery, the painting prompted tragic poster boy of neo-romanticism John Minton to commission his own portrait (fig.16). Despite this success, for the next six years Freud had no solo shows while he endeavoured to master the medium of paint.

Freud's focus on portrait heads during this period allowed him to develop his manipulation of paint to suggest volume and the underlying structure of the human face, while still capturing detail. *Girl in Bed* 1952, one of a series of tender, intimate portraits of Caroline, shows an enhanced sense

15

Francis Bacon
1952
Oil paint on metal
17.8 × 12.7
Tate. Purchased 1952
(missing since 1988)

16

John Minton
1952
Egg tempera on
gesso ground
41 × 26
Royal College of Art
Collection, London

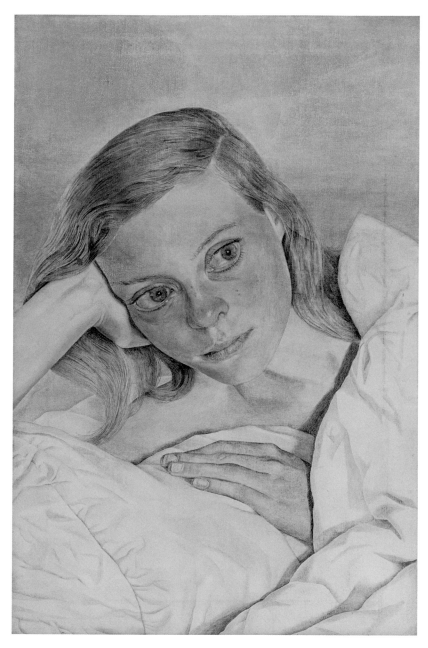

17
Girl in Bed
1952
Oil paint on canvas
45.7 × 30.5
Private collection

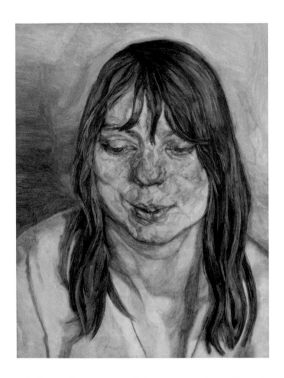

of three-dimensional form, combined with idiosyncratic details such as
freckles and bitten nails (fig.17). Mellor has noted the affinity between
Dostoyevsky's *The Idiot* (1869), which Caroline read to Freud in Paris,
and the barren, material world that Freud portrayed with intense scrutiny.
But in the context of post-war, anti-German feeling, critics regarded his
harsh, unsentimental vision as 'teutonic', as Caroline later observed: 'It
is interesting to note that the many portraits he painted in the forties and
fifties, in what now is considered his most romantic and gentle style, at the
time were seen by many as shocking and violent and cruel.'[7]

Stimulated by the example of Frank Auerbach (introduced to him by Francis
Bacon in 1955 and his closest artist friend from the 1970s onwards), as
well as by the earlier painters Frans Hals (1580–1666) and Diego Velázquez
(1599–1660), Freud turned to the looser, coarser brushstrokes seen in works
such as *Woman in a White Shirt* 1956–7 (The Devonshire Collections and
the Chatsworth Settlement Trustees) or *Woman Smiling* 1958–9 (fig.18),
demonstrating how far he had evolved from the emblematic images of Kitty.
Now worked wet on wet, they suggest a more pronounced interest in plasticity
over line, in the shapes and structures under the skin as well as the blood
coursing through veins. The sensation of inhabiting a body is unmistakable in

18
Woman Smiling
1958–9
Oil paint on canvas
71.1 × 55.9
Private collection

Pregnant Girl 1960–1, Freud's portrayal of Bernadine Coverley asleep while pregnant with his daughter Bella, which emphasises the sheer exhaustion – the weight and feel – of her swelling body and heavy breasts (fig.19). In three self-portraits at this time he experimented further with the representation of the head and face as a series of tonal planes, in images that closely resemble Picasso's cubist sculpture of 1909, *Head of a Woman (Fernande)* (Tate).

Freud's rendering of a human form seen from different viewpoints as it inhabits space aligns his work to a phenomenological understanding of reality, as perceived, tested and known through the body, a sense of the real as formulated during the 1950s by French philosophers such as Maurice Merleau-Ponty (1908–1961).[8] In 1954, influenced by Giacometti, Freud spoke of the invisible yet tangible effect of the human presence in space:

> The aura given out by a person or object is as much a part of them as their flesh. The effect that they make in space is as bound up with them as might be their colour or smell. The effect in space of two different human individuals can be as different as the effect of a candle and an electric light bulb. Therefore the painter must be as concerned with the air surrounding his subject as with that subject itself. It is through observation and perception of atmosphere that he can register the feeling that he wishes his painting to give out.[9]

During the 1950s the naturalism underpinning his early work consolidated into a greater sureness of his identity as a realist painter. Most likely assisted by David Sylvester, he produced an eloquent expression of this position in 'Some Thoughts on Painting', published in *Encounter* in July 1954.[10] This explanation of his work released him from the burden of reiteration or further engagement with mediators of his work unless he chose. In an era of radical change, of philosophical and cultural uncertainty, when the subject and purpose of art was hotly debated, 'Some Thoughts on Painting' provided a proposition or set of anchoring principles against which to justify his subsequent output. Essentially, these 'thoughts' allowed Freud to shed his youthful association with outmoded styles such as surrealism and neo-romanticism, and possibly, as James Hyman has argued, to distance himself from uncomfortably Germanic readings of his in work.[11]

Echoing the nineteenth-century perception of realism expressed by French naturalist writer Émile Zola (1840–1902) as 'nature seen through

a temperament', Freud described his response to the factual world as driven by his own proclivities and feelings:

> The painter makes real to others his innermost feelings about all that he cares for. A secret becomes known to everyone who views the picture through the intensity with which it is felt. The painter must give a completely free rein to any feelings or sensations he may have and reject nothing to which he is naturally drawn. It is just this self-indulgence which acts for him as the discipline through which he discards what is inessential to him and so crystallises his tastes. A painter's tastes must grow out of what so obsesses him in life that he never has to ask himself what is suitable for him to do in art.

Despite Freud's obsession with Caroline, his wild behaviour and the daily presence of Bacon took their toll on the marriage, which ended in 1957. Perhaps acknowledging the destructive aspects of painting those he loved, he stated that 'the painter needs to put himself at a certain emotional distance from the subject in order to allow it to speak. He may smother it if he lets his passion for it overwhelm him while he is in the act of painting.'[12] He may also have wanted to purge his work of the excessive emotion or expression negatively associated with German art. As Hyman has proposed, reviews of his work as 'cruel' and 'perverse' may have led him closer to the French realist tradition. When William Feaver later questioned Freud's tendency to favour the influences of French over German painting in his work, his response was simply 'because it happens to be better'.[13]

The year 1954 can be seen as a pivotal one, when Freud's critical reception was thrown into relief by his representation of Britain, alongside Bacon and abstract artist Ben Nicholson, (1894–1982) at the prestigious Venice Biennale. With fierce debate raging about the direction of art, abstraction and realism were natural enemies. But within realism itself opposing values were at stake, namely the left wing, collective values of social realism supported by critic John Berger, versus the apolitical liberalism (and individualism) underpinning Sylvester's modernist realism. Bacon and Freud's international airing offered Sylvester an ideal opportunity to promote modernist realism as a contemporary vision of humanity connected to a rich and continuing tradition. For Freud, abstraction was too restricting in terms of its ability to elicit a range of responses from the viewer: 'Painters who deny themselves the representation of life and limit

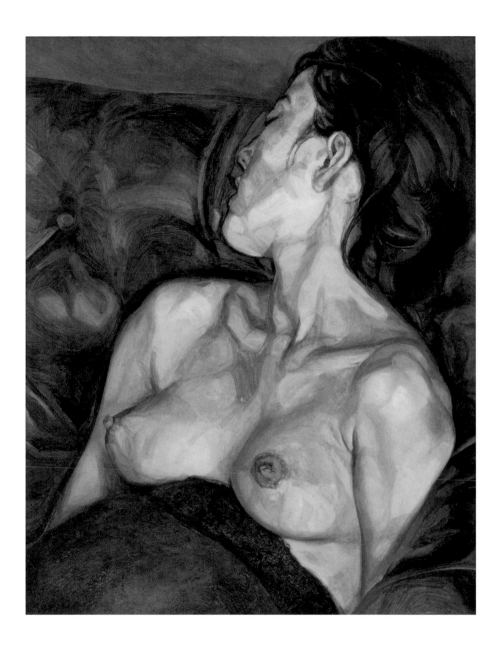

19
Pregnant Girl
1960–1
Oil paint on canvas
91.5 × 91.5
Jacqueline Leland

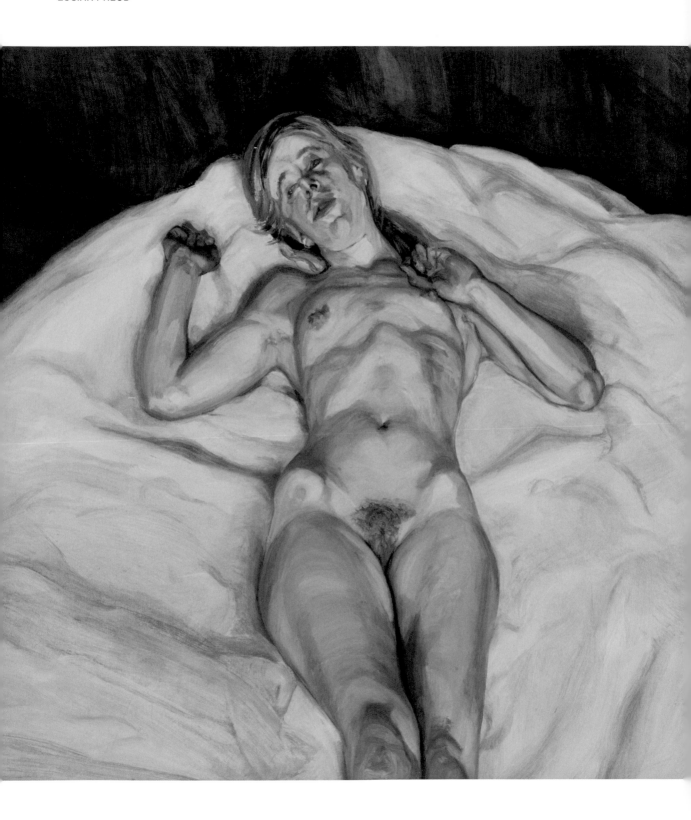

their language to purely abstract forms are depriving themselves of the possibility of provoking more than an aesthetic emotion.'[14]

More than at any other time, in the 1950s and early 1960s Freud appears with Bacon in the guise of Baudelaire's *flâneur*, an aesthete or dandy, representing the last 'flicker of heroism in decadent ages'.[15] Yet, as his remarks on the limitations of aestheticism revealed, this appearance was deceptive. Increasingly preoccupied with the gap between art and life, he acknowledged the possibility of failure in the creative process, and the sense of futility that was the corollary of the intense dedication it entailed:

A moment of complete happiness never occurs in the creation of a work of art. The promise of it is felt in the act of creation but disappears towards the completion of the work. For it is then that the painter realises that it is only a picture he is painting. Until then he had almost dared to hope that the picture might spring to life.[16]

Freud's continuing commitment to observing the human subject as lived-in space led him in the mid-1960s to begin re-evaluating in earnest the European tradition of the female nude (fig.20). His painterly development of the 'naked portrait' would contrast sharply with the proliferation of photographic images of naked women in mass culture, their airbrushed perfection celebrated in the works of Pop artists such as the American James Rosenquist and British artists Peter Blake and Alan Jones. While during the 1950s modernist realism briefly held the international stage, its currency was short-lived. Remaining a cult figure, Freud went to ground in the 1960s and 1970s.

20
Naked Girl
1966
Oil paint on canvas
61 × 61
Collection Steve Martin

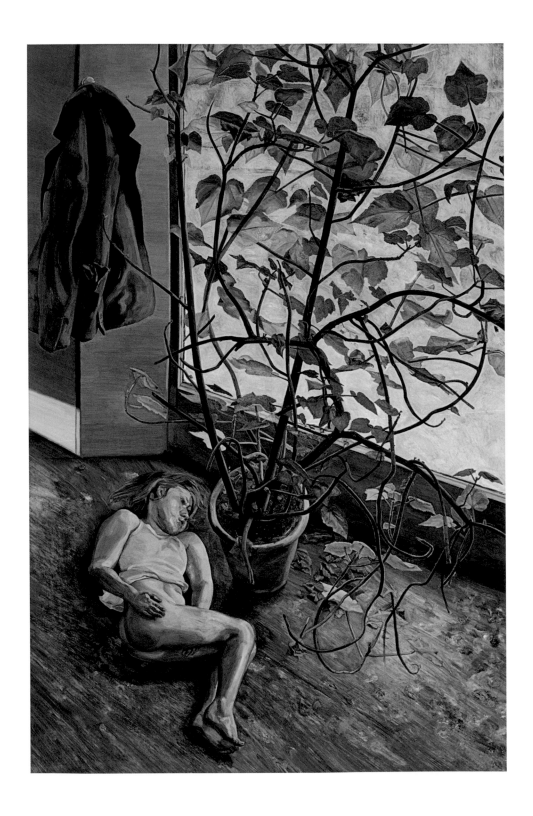

4 THE STUDIO: PROXIMITY AND REFLECTIVE DISTANCE (1960s–70s)

I think a great portrait has to do with the way it is approached … If you look at Chardin's animals, they're absolutely portraits. It's to do with the feeling of individuality and the intensity of the regard and focus on the specific. So I think portraiture is an attitude. Painting things as symbols and rhetoric and so on doesn't interest me.[1]

IN THE EARLY 1960s Freud travelled abroad to see for himself work by old masters he admired – to Alsace for Matthias Grünewald's Isenheim Altarpiece 1512–16; Montauban for the Musée Ingres; Montpellier for Gustave Courbet's work; Castres for Francisco Goya's paintings; Haarlem in the Netherlands for Frans Hals; and Paris with Bacon in 1967 for the Jean-Auguste-Dominique Ingres exhibition. After this he rarely left London. During the 1960s and 1970s, intensely protective of his private life, he gave himself up to the introspective world of the studio, the site of his reality. This chapter considers the idea of proximity in Freud's work, in terms of painting the life of the studio and its environment, and the proximity or close perception of his subjects, human and otherwise. It also refers to Freud's attachment to West London and his association with the 'School of London', a loosely connected group of individual figurative painters centring on Auerbach, Bacon, Leon Kossoff and Mike Andrews (1928–1995).

21

Large Interior, Paddington
1968–9
Oil paint on canvas
183 × 122
Museo Thyssen-
Bornemisza, Madrid

Freud's claustrophobic, enclosed world, with its bare furnishings and pessimistic sensibility, appeared at odds with the expansive, inclusive approach to art and society that characterised the 1960s and 1970s, with their optimism, hedonism and social and political radicalism. Freud's commitment to realism and the figure jarred with the coolly conceptual

and minimal art that dominated the international art scene during these decades. His exploration of the life of the studio contrasted with 'post-studio' practice, which involved rapidly changing approaches to art production and the rejection by artists of the studio, both as a workplace – a frame for the formation and display of the artist's identity – and as a signifier of creativity and (particularly male) mystique.[2]

Despite a coterie of loyal followers, Freud's work lost critical favour – dismissed as irrelevant or unpalatable. For example, Isobel, one of his daughters by Suzy Boyt, depicted in *Large Interior, Paddington* 1968–9 curled on hard, bare floorboards under an over-sized Zimmerlinde (or African hemp) plant, was thought to be portrayed as a victim of abuse (fig.21). But Freud seemed to care little about criticism or the art establishment. Like the reclusive artist in Albert Camus's *Jonas ou l'artiste au travail* published in 1957, he shunned the social engagements of the art world and – despite bohemian episodes in Soho with Bacon in the early 1960s – devoted himself to the life of the studio.[3]

Freud's decisions and behaviour were governed by a desire to live life according to his own rules, a wilful, almost Nietzschean insistence on self-determination sharpened by a deeply felt post-Belsen, post-Hiroshima cultural pessimism, which he expressed in a rare, early statement with uncharacteristic directness in 1963:

> When man finally sealed his destiny by inventing his own inevitable destruction he also gave art absolute gravity by adding a new dimension: this new dimension, having the end in sight can give the artist supreme control, daring and such awareness of his bearings in existence that he will (in Nietzsche's words) create conditions under which 'a thousand secrets of the past crawl out of their hideouts – into his sun'.[4]

For Freud, limiting his practice to his immediate surroundings enabled him to focus in on subject matter – people, animals, plants, things – without the distractions (and perhaps false consolations) that the culture of these decades was pouring forth so abundantly (fig.22). As he later commented:

> My idea of travel is downward travel really. Getting to know where you are, better, and exploring feelings that you know more deeply. I always think that thing 'knowing something by heart' gives you a depth

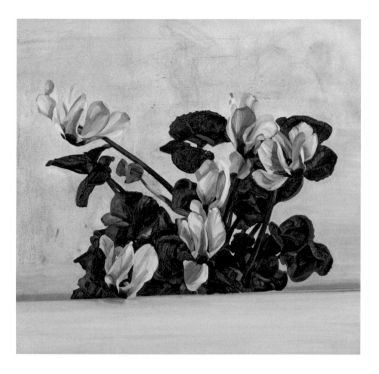

22
Cyclamen
1964
Oil paint on canvas
45.7 × 49.2
Private collection

of possibility which is more potential than seeing new sights, however marvellous and exciting they are.[5]

Freud's disinterest in changing art styles or movements and commitment to the solitary studio were shared by other School of London painters. Auerbach identified Giacometti as the key model for this private, interior pursuit:

> He established that one went to a studio and worked there, and it wasn't any longer a question of movement, it wasn't any longer a question of making discoveries for other people, it was really a question of integrity at a very deep level of amusing oneself – which I think was a new note.[6]

Freud's portrayal of the self-reflexive interior life of the studio draws on Giacometti's example, as well as the realism of traditional Flemish genre scenes and Matisse's archetypal studio series. It has been regarded as a metaphor for both the painter and painting itself.[7] But it might simply be seen as a refuge from everything irrelevant or detrimental to the deeper task in hand.

From as early as the mid-1940s, in fact, Freud had deliberately marginalised himself and his practice, mostly residing in the then seedy and

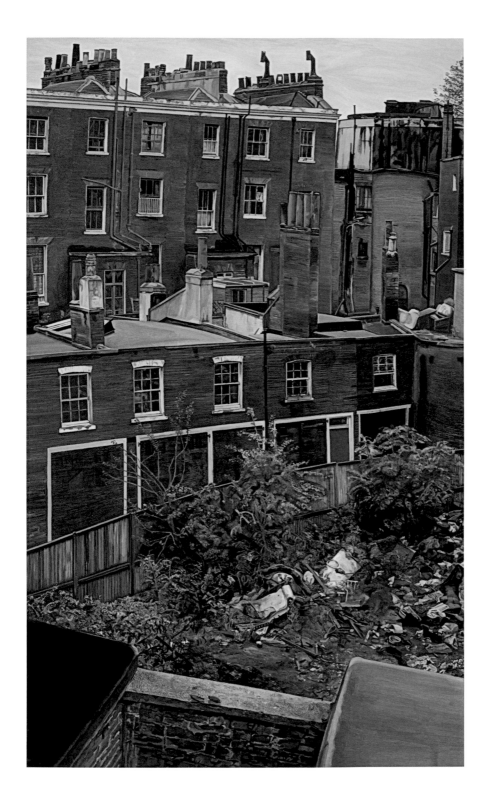

23
**Wasteground with Houses,
Paddington**
1970–2
Oil paint on canvas
167 × 101
Private collection

rough working-class Paddington area of West London, only later moving to more genteel parts of neighbouring Notting Hill. For nearly two decades he lived in Delamere, Paddington's most bombed-out, edgy district, until relocating to cramped quarters in Soho's Clarendon Crescent in 1962. Forced to move again in 1965, he found larger premises in Gloucester Terrace, where he painted *Large Interior, Paddington*. He stayed there for seven years, subsequently spending five years in a modest studio in nearby Maida Vale. In 1977 he moved to a spacious top-lit studio in Notting Hill, enabling him to produce larger more ambitious works, notably *Large Interior W11 (After Watteau)* 1981–3 and sizeable naked portraits of Leigh Bowery and Sue Tilley in the early 1990s.[8] From the 1960s his increasing commitment to the life of the studio signified that, for him, there was no other life. As he later emphasised: 'Nothing ever stands in for anything … Nobody is representing anything. Everything is autobiographical and everything is a portrait, even if it's a chair.'[9]

Window views occasionally puncture the confined space of his pictures, giving some clue to geographic location, with the city rendered in the distinctive colour and tones of his palette. Freud's browns, greys, creams and depiction of cool, northern light strongly evoke a sense of place, underscored by the matter of fact reference to postal codes – W9, W11– in his titles. Occasionally he turned his attention to still-life subjects or his immediate environs, such as the utterly mundane yet visually rich and melancholic *Wasteground with Houses, Paddington* 1970–2, or the intricate, complex, woven tapestry of vegetation in his garden. But such external forays were exceptions (fig.23).

In the 1940s the idea of a 'School of London' enabled critics to assert the claims of contemporary British art in the face of its better-established rival, 'L'École de Paris'. Subsequently denoting figurative art, the term gained currency when used by American painter R.B. Kitaj in 1976 to promote artists dedicated to the human form, notably Francis Bacon, Frank Auerbach, Leon Kossoff, Mike Andrews and Lucian Freud.[10] While sharing a disdain for such labels, these artists were nevertheless all attempting to paint their experience of the world, a challenge articulated by Bacon: 'To me, the mystery of painting today is how can appearance be made. I know it can be illustrated, I know it can be photographed. But how can this thing be made so that you catch the mystery of appearance within the mystery of making?'[11] Moreover, these artists were committed

to the value of representation itself, to the potential of paint as a medium of authenticity and its ability to convey inner or 'essential' truths.

Like Giacometti and, before him, Paul Cézanne (1839–1906), Freud, Auerbach and Kossoff engaged in a protracted creative process overshadowed by existential doubt. Anxiety registered in the paint itself, applied tentatively or by rigorous, self-imposed corrective procedures. Kossoff and Auerbach typically equate the physical subject with the materiality of paint, loaded in layers and loosely coiled on the canvas. For Auerbach these layers produce a visual chaos as he struggles to convey the experience of another human being: 'I not only don't see my paintings when I am doing them. I'm really surprised at finding the composition of them afterward.'[12] In different ways these painters have been preoccupied with representing the body as lived experience, its materiality, tension and fatigue, or – in Freud's case particularly – a sense of animal abandon. Like Auerbach, during the 1960s and 1970s Freud increasingly focused on painting those he knew intimately. For Auerbach this proximity was both urgent and essential for survival:

> This act of portraiture, pinning down something before it disappears seems to be the point of painting. Our lives run through our fingers like sand, we rarely have the sense of being able to control them, yet a painting by a good painter, say Manet, Hogarth or Velasquez, represents a moment of grasp and control of man over his experience. That seems to make life more bearable.[13]

Working across a range of genres, these artists' main preoccupation has been the human subject, inspired by the universal themes as revealed and constantly reinterpreted by the old masters of the western tradition of art, such as Rembrandt, Velázquez and Van Gogh. While drawing on this authoritative tradition, they strenuously sought to avoid repetition or imitation, resulting in an awkwardness that resists easy solutions or cliché. London features in their work as more than just a subject or backdrop, but signals a profound, Baudelairean commitment to the urban context and the passing experience as proof of existence.[14]

During this period Freud began to turn his attention fully to the naked human subject, painting the whole body for the first time in his attempt to represent a person more truthfully. As for Cézanne, this involved looking at surfaces closely and finding an equivalent painterly mark, bringing together both visual

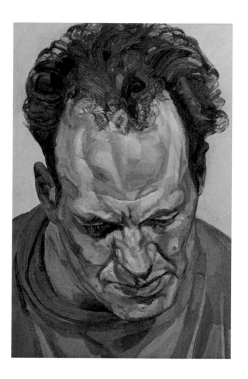

24
Frank Auerbach
1975–6
Oil paint on canvas
40 × 26.5
Private collection,
courtesy Ivor Braka Ltd

perception and feeling, a process best illustrated by comparing Cézanne's *Self-Portait* c.1880–1 (National Gallery, London) and Freud's portrait of Auerbach, with its palpable concentration on the dome of the sitter's forehead (fig.24). While there is always an element of subjugation of the sitter as subject of the artist's work, Freud began to recognise the complexity of portraiture as a collaborative endeavour, an oscillation between the observer and the observed, the image produced as much by the model as by himself. For example, *Naked Girl* 1966 gives a sense of the model's individual uniqueness precisely through her choice of pose. In 1974 he revealed: 'I get my ideas for pictures from watching the people I want to work from moving about naked. I want to allow the nature of my model to affect the atmosphere, and to some degree the composition.'[15] He later remarked about his human subjects: 'I didn't want to get just a likeness like a mimic, but to portray them, like an actor', thus accepting the limitations of mere reflection, and his own contribution to 'likeness'.[16] But ultimately, the authenticity of the image would arise from its particularity, as the product of a specific human encounter.

Reworking existing subjects, during the 1960s and 1970s Freud self-consciously extended his understanding of perception and pursuit of authenticity through representation. In particular through a series of

self-portraits and portraits of his mother his pursuit of 'likeness' or representation of inner life pushed the 'intensity of the regard and focus' to another level. As Norman Bryson has noted, the etymology of the word 'regard' in French suggests more than the act of looking, its prefix indicating

> an act that is always repeated ... an impatient pressure within vision, a persevering drive which looks outward with mistrust (*reprendre sous garde* to re-arrest) and actively seeks to confine what is always on the point of escaping or slipping out of bounds. The regard attempts to extract the enduring from the fleeting process; its epithets tend towards a certain violence (penetrating, piercing, fixing), and its overall purpose seems to be the discovery of a second (re-) surface standing behind the first, the mask of appearances.[17]

Primarily, Freud's self-portraits evidence his attempt at this time to find a way of capturing likeness, perhaps most difficult when applied to the subject of the self. Self-portraits rely on the mirror, and now Freud made this more explicit, exaggerating the elongating effect of the reflected self through a series of pictorial strategies that both affirm and refute the possibility of self-portrayal. Like Parmigianino's remarkable *Self-Portrait in a Convex Mirror* c.1523–4 (Kunsthistorisches Museum, Vienna), which depicts the artist's reality as shifting and chaotic (and was seen by his contemporaries as monstrous), Freud used optics to suggest an unstable world. In *Reflection with Two Children (Self-Portrait)* 1965 – the first time he used 'reflection' in a title – he regards himself sceptically in a mirror on the floor, looming vertiginously over two tiny portraits of his children Ali and Rose Boyt in the foreground (fig.25). A frame at the bottom of the picture separates Freud in space and time from the smiling, diminutive children, questioning the feasibility of the image as a reflection, and by implication his ability to represent two simultaneous events in painting, since the mirror can only reflect the transitory present. The idea of foregrounding the children came from a reproduction of the tomb of the dwarf Seneb and his family in the Cairo Museum, and this perhaps enhances the otherworldly figure of their father, who appears cold and menacing, a Twilight Zone spectre, reminiscent of Edvard Munch's sinister *Self-Portrait with Cigarette* 1895 (National Museum of Art, Architecture and Design, National Gallery, Oslo).[18]

Interior with Hand Mirror (Self-Portrait) 1967 reflects the artist's face in a small mirror secured in a sash window (fig.26). Light both illuminates his

25
Reflection with Two Children (Self-Portrait)
1965
Oil paint on canvas
91.5 × 91.5
Museo Thyssen-Bornemisza, Madrid

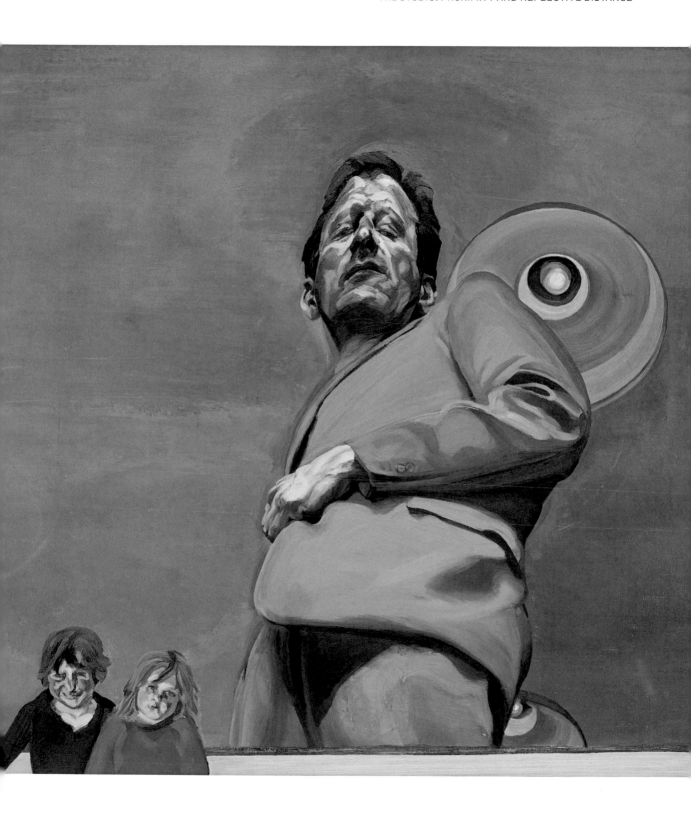

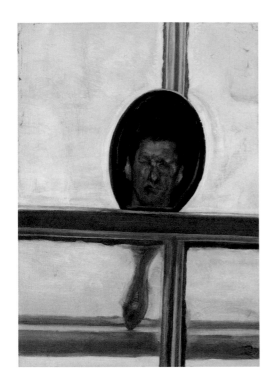
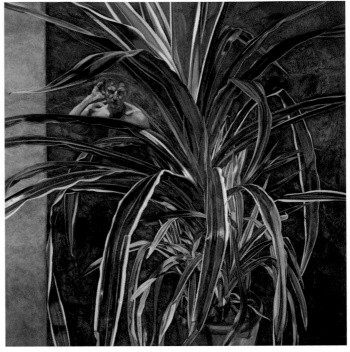

features and impedes his vision, his closed eyes denying the mirror its power to reflect the present moment as perceived by the eye.[19] Freud's *Interior with Plant, Reflection Listening (Self-Portrait)* 1967–8 (fig.27) revisits earlier self-portraits twinned with plant life such as *Man with a Thistle (Self-Portrait)* 1946 (Tate). Partially obscured behind the leaves of a large potted plant, the artist appears truncated and at a distance, cupping his ear, straining to hear. Perhaps, as Andrew Benjamin has suggested: 'In looking at this self-portrait, in looking at the ear, in hoping to "hear" the painting, the question of the self-portrait itself is being asked.'[20] In a later work, *Reflection (Self-Portrait)* 1981–2, the artist's head and shoulders are shown in profile, his eyes glancing sideways to see his reflection, with what has been described as a 'characteristically eagle-like stare' (fig.28).[21] In painting, as Bryson has proposed, the furtive sideways glance interrupts the fixed or prolonged position and ordered worldview suggested by the gaze. In western art the glance plays the role of the 'trickster' or 'saboteur', working against the myth of the timeless or essential copy of nature, and proposing desire and the body.[22]

Freud had produced self-portraits since 1939, but here he draws attention to the device of the mirror, as if to make more transparent the artificiality of the

26

Interior with Hand Mirror (Self-Portrait)

1967

Oil paint on canvas

25.5 × 17.8

Private collection

27

Interior with Plant, Reflection Listening (Self-Portrait)

1967–8

Oil paint on canvas

121.8 × 121.8

Private collection

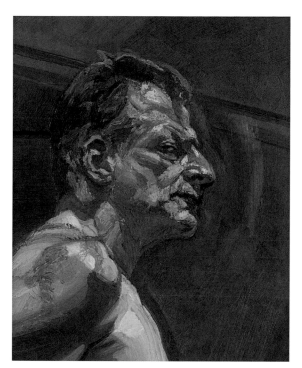

28
Reflection (Self-Portrait)
1981–2
Oil paint on canvas
30.5 × 25.4
Private collection

29
Narcissus
1949
One of four unpublished
illustrations for Rex
Warner's *Men and Gods*
Ink on paper
22.3 × 14.5
Tate. Bequeathed by Pauline
Vogelpoel, Director of the
Contemporary Art Society,
2002, accessioned 2004

image and the difficulty of achieving a 'likeness' of the self. Unlike that favourite subject of classical art, Narcissus – who died hypnotised by his own reflection – Freud breaks the spell, casting doubt on his ability to see into his own soul. He drew his own Narcissus in 1950 perhaps to signal his desire for self-sufficiency and independence (fig.29). These later, spatially distorted self-portraits suggest a dialogue with the art-historical conventions of self-portraiture and probably owe something to Bacon's use of mirrors to reflect corporeal separation in works such as *Portrait of George Dyer in a Mirror* 1968 (Museo Thyssen-Bornemisza, Madrid).[23] All have the frisson of Sigmund Freud's 'uncanny' (*unheimlich*), which he first perceived when failing to recognise his own reflection or double in a swinging glass door.[24] They might also be read in the context of the 'mirror stage' – a concept evolved by the psychoanalytic theorist Jacques Lacan between the mid-1930s and the 1960s – and its role in self-identification. Lacan proposed that the mirror sets up a tension or rivalry between the felt and perceived body, and that this is resolved by the formation of the Ego, representing a moment of imaginary self-mastery. But he also suggested that the formation of the Ego via recognition in a mirror is the product of a false recognition or misunderstanding (*méconnaissance*).[25] As Joanna Woodhall has argued, Lacan regards the self-portrait as an alienated distortion – in effect,

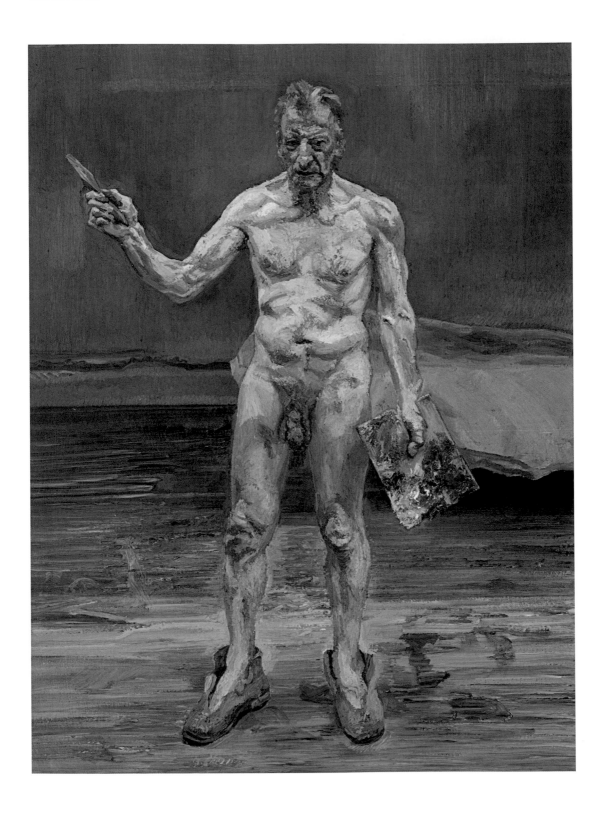

the mirror alienates the subject from itself – concluding that in the twentieth century the portrait has assumed the ability to confirm the loss of self instead of its consolation.[26] Later, when commenting on *Painter Working, Reflection* 1993 (fig.30), a raw self-portrait of his aging body naked but for a pair of boots, Freud revealed: 'The way you paint yourself, you've got to try and paint yourself as another person. With self-portraits "likeness" becomes a different thing. I have to do what I feel without being an expressionist.'[27]

The death of Freud's father in 1970 prompted a sharper sense of mortality and impermanency that affected his work.[28] In the early 1970s, in response to his mother's severe grief-induced depression, he began painting her regularly, at times almost daily, and continued doing so until the mid-1980s. Previously, he had spurned his mother's interest and affection, finding it intrusive. But now her passive self-absorption changed their relationship, as he later explained: 'If my father hadn't died I'd never have painted her. I started working from her because she lost interest in me: I couldn't have, if she had been interested.'[29] The artist's mother is a well-established subject in the western tradition of art, and Freud's unsentimental pictures have been compared with those of Rembrandt, renowned for conveying the sitter's interiority. Freud's images of his mother depict her laid out as if for burial. Prefiguring her death, Freud emphasises the impact of her state of mind – extreme inertia caused by grief and lost hope – on her physical body (figs 31, 32). While in the past portraiture was held up as having the power to overcome death and absence through its representation of likeness, in these extraordinary works Freud suggests the opposite, concentrating instead on his mother's frailty and mortality.

These experiments built on Freud's fascination with the complexity of representation, which is even more intriguingly expressed in pictures such as *Large Interior W9* 1973. This juxtaposes portraits of his mother, clothed and seated in the foreground, with his then lover, Jacquetta Eliot, reclining semi-naked on a bed, apparently in post-coital reverie (fig.33). Recalling the compressed space of *The Tempest* 1505 (Gallerie dell'Accademia, Venice) by Giorgione (1470–1510), the sitters – both intimate with the artist but not with each other – are compressed spatially, so that Jacquetta in the background appears in close proximity to Freud's mother, occupying the same space but not simultaneously.[30] Proximity of those he loved had become crucial to Freud's work, but his promiscuity created conflict and jealousies that both gave his work its intensity and caused him distress and disruption. He needed proximity, but needed protecting from it.

30
Painter Working, Reflection
1993
Oil paint on canvas
101.2 × 81.7
Private collection

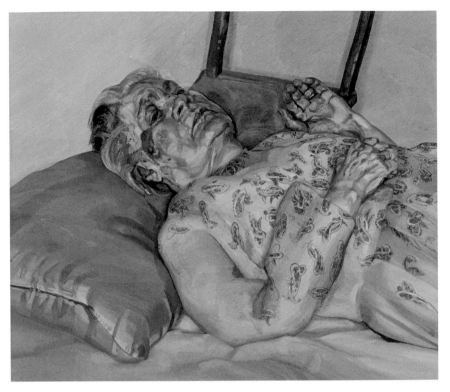

31
The Painter's Mother Resting III
1977
Oil paint on canvas
59.1 × 69.2
Private collection

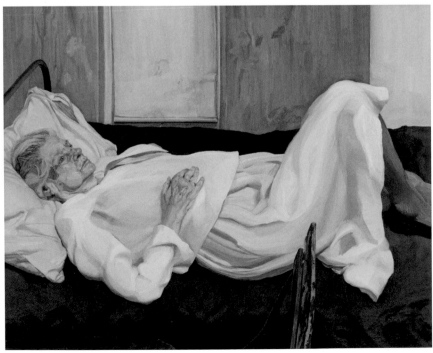

32
The Painter's Mother Resting
1982–4
Oil paint on canvas
105.4 × 127.6
Private collection,
courtesy Richard Nagy,
Dover Street Gallery

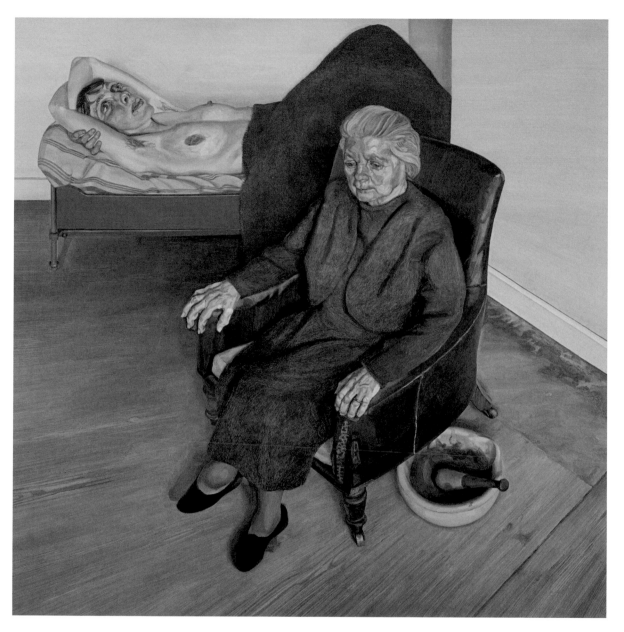

33
Large Interior W9
1973
Oil paint on canvas
91.4 × 91.4
The Trustees of the
Chatsworth Settlement

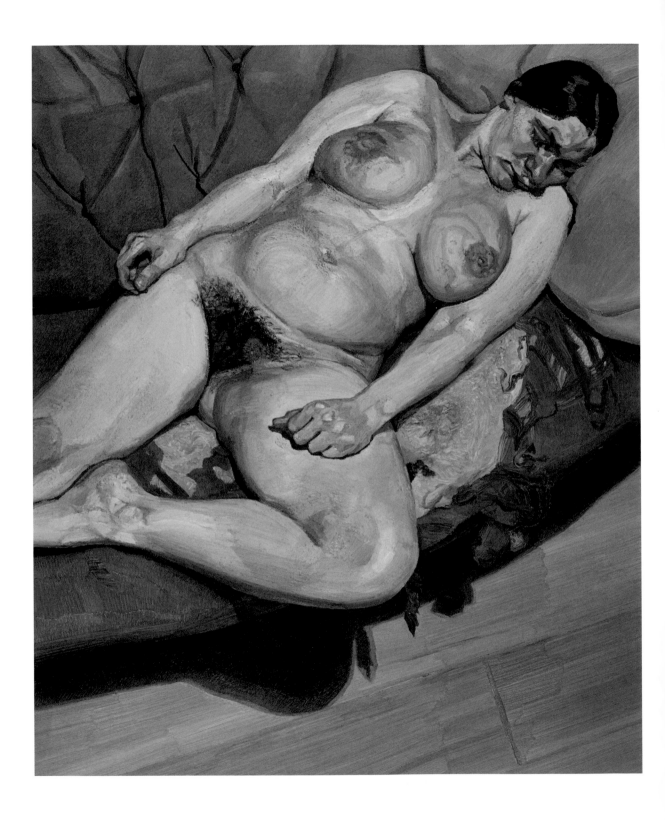

5 THE NAKED PORTRAIT (FROM THE 1980s)

I think the nudes have to do with making a larger, more complete portrait. It's a more specific portrait. I can simply see more of the person. Anyone can put on different clothes. The naked body is somewhat more permanent, more factual.[1]

ARGUABLY, the defining achievement of Freud's career was his explosive development of the 'naked portrait' during the 1980s and 1990s. In these works, unprecedented in their candour, he fully exploited the properties of paint to represent the human animal (fig.34). In 1976 he began using Cremnitz white, a pigment heavy with lead, less oily than other whites. It became his code for representing flesh, as he told Lawrence Gowing: 'I want the paint to work as flesh ... I would wish my portraits to be of the people, not like them ... As far as I am concerned the paint is the person. I want it to work for me as flesh does.'[2] Freud's ambition to make the painting as real as possible took on new meaning, as his friend John Richardson concluded in 1993: 'Isn't the potential of paint to become flesh and not merely to simulate it what all Freud's late works celebrate? Hence their amazing palpability. Transubstantiation through art.'[3]

34
Naked Portrait II
1980–81
Oil paint on canvas
90 × 75
Private collection

Freud's return to the public eye in the 1980s was underpinned by the eloquent writing of Lawrence Gowing and Robert Hughes, who helped establish a critical framework for his oeuvre.[4] Importantly, in the catalogue essay accompanying his British Council retrospective of 1987 Hughes positioned Freud within the great tradition of European painting, as heir to its crisis in the nineteenth century, when Gustave Courbet

(1819–1877), Edgar Degas (1834–1917) and Auguste Rodin (1840–1917) shocked the public with their realist attack on the 'ideal' nude. Several major exhibitions re-established Freud's international reputation and generated a new and wider audience for his work in the UK and America. His naked portraits in particular touched a nerve in the culture and sparked intense critical debate. While they provoked a backlash from feminists, who condemned Freud as a misogynist, for others they proved that painting still had the power to comment profoundly on the human condition. This chapter considers the achievement of the naked portraits and their controversial critical reception.

Freud's identity as an 'authentic' artist won him respect from wider audiences, but this identity was under attack from the growing critique of established notions of artistic (and specifically male) 'genius'. Freud maintained the enchantment of the studio – in Hughes's words, Freud's 'cave of making' – reinforcing the myth of the primordial male artist, his unrestrained libido nourishing his creative potency.[5] Withholding biographical detail and the identity of sitters, and the clandestine comings and goings and apparently unorthodox relationships implied by his paintings, such as *Naked Man with his Friend* 1978–80, aroused prurient curiosity (fig.35). Among a public ever more voracious for scandalous celebrity exposés, the lack of information about his models stimulated speculation.

Freud's aim was to reveal the complete human animal as reflected in unselfconscious, relaxed poses. Increasingly, he adopted a somatic approach, attempting to convey the sensation of inhabiting a body from the inside. From the early 1970s he started relying more on the sitter's participation, fascinated by human behaviour. Since childhood he had felt a strong affinity with animals, particularly horses, and kept birds and dogs as pets, attributing this hands-on interest in zoology to his grandfather's legacy. He was probably also aware of the nascent field of ethology – the study of human behaviour by observation, as popularised by Desmond Morris in his controversial book, *The Naked Ape: A Zoologist's Study of the Human Animal* (1967). For Freud the real person was the 'naked ape', stripped of external attributes, social pretence or acquired mask. Freud described his practice as being 'like wild-life photography – by one of the animals'.[6]

In 1987 Freud emphasised the primacy of animal instinct in relation to art: 'The task of the artist is to make the human being uncomfortable, and yet

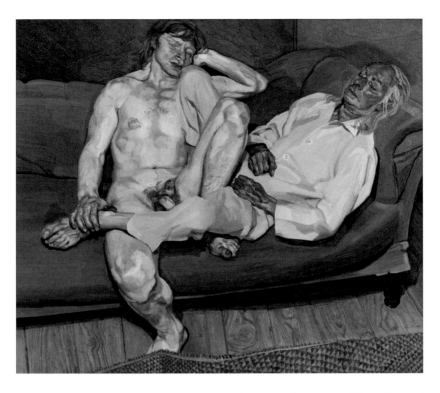

35
Naked Man with his Friend
1978–80
Oil paint on canvas
90.2 × 105.4
Private collection

we are drawn to a great work by involuntary chemistry, like a hound getting a scent; the dog isn't free, it can't do otherwise, it gets the scent and instinct does the rest.'[7] In later years he suggested a quasi-scientific approach to the human subject:

> Living people interest me far more than anything else. I'm really interested in people as animals. Part of my liking to work with them naked is for that reason … and it's also very exciting for me to see the forms repeated right through the body and often in the head as well. I like people to look as natural and as physically at ease as animals, as Pluto, my whippet.[8]

Freud's process depended entirely on having the model present, even when he was working on other areas of the picture. He had spoken in 1954 of his perception of a person's 'aura', a spiritual rather than physical emanation.[9] To suggest lived experience in space, Freud – like Cézanne – considered his subject from different viewpoints. In 1982 Gowing argued that Freud was 're-enacting' a sense of the direction and coherence of each form through a process akin to 'echo-sounding', taking readings from a number of positions. As the artist explained:

I don't want to miss anything that could be of use to me. I often put in what is found round the corner from where I see it, in case it is of use to me ... Towards the end I am trying to get rid of absolutely everything I can do without.[10]

This integration of the figure with surrounding space was influenced by Giacometti, and pursued by other School of London painters, as Leon Kossoff made clear: 'The fabric of my work through the last forty years has been dependent on those people who have so patiently sat for me, each one uniquely transforming my space by their presence.'[11]

Many critics have perceived a breath of life in Freud's figures, investing him with Pygmalion's power to bring art to life.[12] Yet the stillness of his sitters and their physical imperfections have suggested death and the tradition of *nature morte* (literally 'dead nature'), the grainy surfaces and areas of sometimes densely applied brushwork a constant reminder of the artificiality of painting. Sitters yield their bodies to another's gaze – to Freud's and the viewer's – but often remain aloof, remote, daydreaming or wrapped up in themselves. Despite strenuous effort, Freud fails to deliver total insight into another person, poignantly reminding us that we are alone. As Marina Warner observed in 1988, 'By transgressing against common feelings of intimacy and privacy, Lucian Freud has paradoxically managed to restore to the naked body its character as the inalienable possession of the individual.'[13]

In the 1980s the growth of feminist critical theory supported new and often angry readings of Freud's work, which have persisted. His 1954 statement, 'a painter must think of everything he sees as being there entirely for his own use and pleasure', seemed to further justify interpretations of his naked portraits as the exploitative products of a sexist old man. In a scathing review, critic and expert on nineteenth-century realism, Linda Nochlin, sought to expose Freud as an archetypal 'Great White Western Male Artistic Genius', capable only of painting old or fat women as 'grotesque', dismissing his entire exhibition at the Metropolitan Museum of Art in New York in 1994 as 'authoritarian and patriarchal, spiced with a dash of transgressiveness'.[14]

Freud's interest in animal nature and his numerous illegitimate children perpetuated his rakish reputation. His models appeared passive and listless, prompting critics to read the mottled, intricately painted rawness of the skin and flesh, with its blotches, veins, swellings and other imperfections,

as signs of the artist's moral bankruptcy. Had the priapic artist exhausted his models? With eyes closed or averted, his mostly female models appeared submissive, subjected to the male gaze. Frequently he viewed the model from above, apparently 'lording' it over his victims.[15]

In the 1980s a number of sitters broke their silence to speak about the stress Freud's process placed on them. Ann Dunn, for instance, revealed the mental pain inflicted, saying that she had felt 'devoured and digested and regurgitated almost and it also, for myself, gave me acute anxiety'.[16] Interviewing Freud in the early 1990s, William Feaver questioned this vampirism. The artist responded:

> As they tire I get more energy. I feel that I have to outlast them. I'm doing what I want, completely, when I'm working: the activity where my hopes lie. And when *they* get tired I feel that my initial energy will perhaps lift them to go on a bit, but I've noticed it's more than that: that their fatigue is apt to enliven me.[17]

While Freud's sitters routinely endured arduous sessions, often four or five hours at a time over many months or even years, they mostly did this willingly, intrigued by the painter's process and enthralled by his company. That they are often expressionless might be taken as contradicting his declared interest in interiority. However, Freud aimed to reveal the person through their skin, as David Cohen has suggested: 'The stretched torso of Freud's supine women seem to take on facial features. The flesh is truly charged with personality.'[18]

Talking to Hughes in 1987, Freud articulated a new interdependency between himself and his models:

> The painting is always done very much with their co-operation. The problem with painting a nude, of course, is that it deepens the transaction. You can scrap a painting of someone's face and it imperils the sitter's self-esteem less than scrapping a painting of the whole naked body. We know our faces after all ... I am only interested in painting the actual person; in doing a painting of them not in using them to some ulterior end of art. For me, to use someone doing something not native to them would be wrong.[19]

Hughes noted a distinct lack of erotic charge in most of the naked portraits, comparing Freud's apparently detached depiction of female

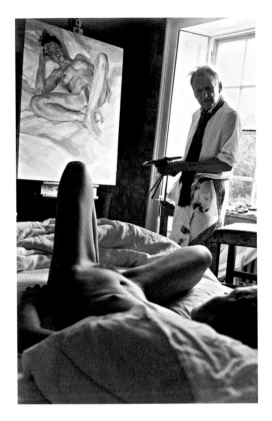

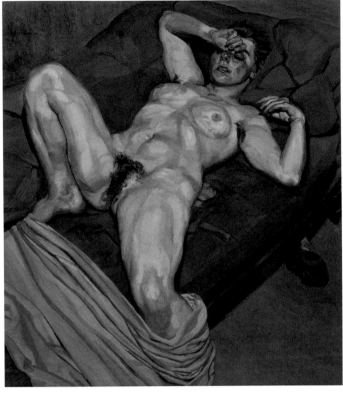

genitalia, like the face, as part of the whole person, with Courbet's realistic but explicitly erotic *L'origine du monde* 1866 (Musée d'Orsay, Paris), so shocking it was not exhibited for over a century. However, later photos of Freud working with his models do nothing to dispel a feminist sense of unease (fig.36). Freud was inspired by the absence of shame in Courbet's nudes, recalling a work he first saw in the early 1960s in the Musée Fabre, Montpellier: 'Les Baigneuses, that marvellous nude going into the forest, like a rugger player pushing off others, lots of foliage, and the woman beside her, one stocking off, one at her ankle. I like Courbet, his shamelessness.'[20] Interestingly, Ellen Handler Spitz has recently compared Freud's refusal to accept shame with his grandfather's psychoanalytic practice, equating the requirement of patients under analysis to say whatever they are thinking – however shameful – with Freud's subjects, who in opening themselves up reveal 'the depths of our essential frailty'.[21]

Some American critics denounced Freud's overt carnality as monstrous, seeing his naked self-portrait, *Painter Working, Reflection* 1993, as the

36
David Dawson, Freud in his studio, 2005

37
Portrait of Rose
1978–9
Oil paint on canvas
91.5 × 78.9
Private collection

depiction of an ageing satyr. *Vanity Fair* gleefully reported his reputation as 'Lucifer' Freud, the 'ancient terrible' and Mephistopheles of modern art.[92] They deemed the naked portraits of his daughters – Annie, Bella, Esther and Rose – as particularly offensive, proof of his depravity and amorality. His *Portrait of Rose* 1978–9, aged twenty-one, caused particular consternation (fig.37). Presenting Rose reclining on her back with legs erotically splayed, a shoe under the couch (a traditional symbol of a used and discarded woman), the work offended feelings of common decency.

Freud later addressed what he felt had been a gross misreading of these portraits. Since he was an absentee father, the paintings had allowed him to spend time together with his children. Painting his daughters naked had felt natural to him:

> For me, painting people naked, regardless of whether they are lovers, children, or friends, is never an erotic situation. The sitter and I are involved in making a painting, not love … Besides, there is something about a person being naked before me that invokes consideration – you could even call it chivalry – on my part: in the case of my children, a father's consideration as well as a painter's.[23]

In 1992, countering negative critical opinion of Freud and his work as cold-hearted, Feaver stressed the tender, compassionate aspect of his subjectivity.[24] According to Feaver, love of humanity – its uniqueness, particularity and vulnerability – was his prime motivation.

While choosing not to paint the heterosexual naked male, Freud reversed established gender roles in a number of paintings, notably in *Painter and Model* 1986–7, which portrays his lover and model Celia Paul, in her role as a painter, standing beside a reclining naked male model (fig.38). With brush in hand, Celia Paul is wearing a paint-encrusted smock and her creative energy is crudely suggested by the paint that spurts from a tube under her foot. Later, in *The Painter Surprised by a Naked Admirer* 2004–5 (fig.39), Freud appears bemused as a naked model clutches his thigh, turning on its head the lasciviousness of Lovis Corinth's *Self-Portrait with Model* 1903 (Kunsthaus, Zurich).

In 1990 Freud was introduced to the outrageous Australian performance artist Leigh Bowery (1961–1994), who sat for him until his untimely death in 1994. Bowery's flamboyant physicality and readiness to sustain unusual

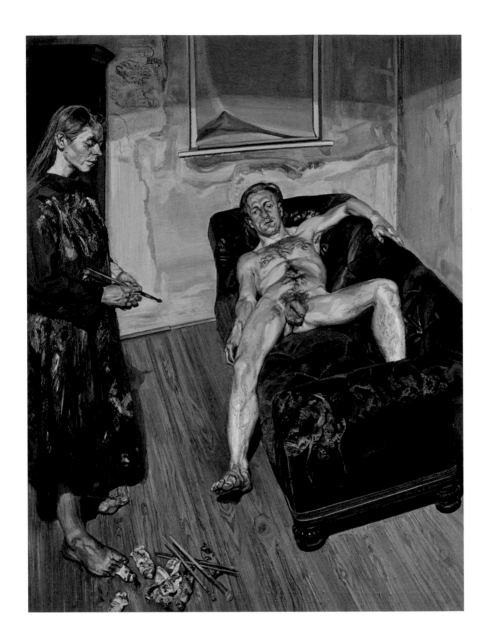

38
Painter and Model
1986—7
Oil paint on canvas
159.7 × 120.7
Private collection

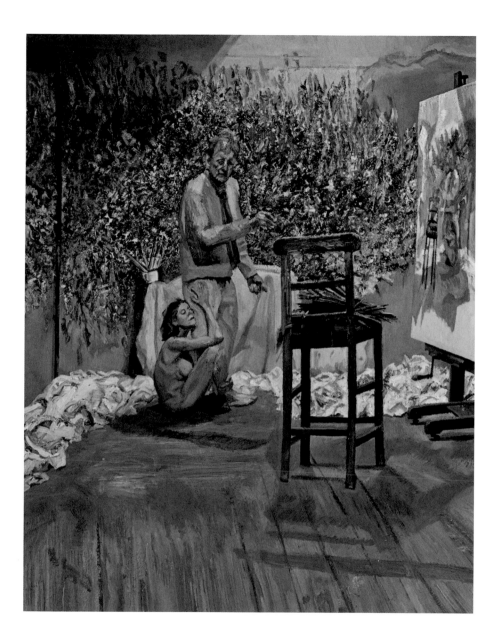

39
The Painter Surprised by a Naked Admirer
2004–5
Oil paint on canvas
62.5 × 132
Private collection

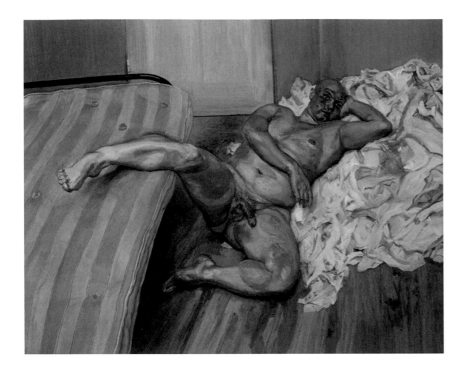

poses encouraged Freud to introduce a baroque verve and theatricality to his treatment of the naked portrait (fig.40): 'He was a remarkable model because he was so intelligent, instinctive and inventive, also amazingly perverse and abandoned.'[25] In these pictures Freud more confidently referenced art-historical precedents. For example, Bowery's back in *Naked Man, Back View* 1991–2 (fig.41) is a coarse reworking of Ingres's famously beautiful *Valpinçon Bather* 1808 (Musée du Louvre, Paris). The staged *And the Bridegroom* 1993 shows Bowery with his seamstress, collaborator and later wife, Nicola Bateman, sleeping on a theatrically draped bed (fig.42). With its limbs afloat above a sea of floorboards, the work has been compared with Théodore Géricault's (1791–1824) epic *Raft of the Medusa* 1824 (Musée du Louvre, Paris).[26] Later, in a series of naked portraits of Bowery's friend Sue Tilley, an official at the Department of Health and Social Security, he transformed Rubens's celebration of feminine flesh into a contemporary vision, both glorious and abject. Drawn to Tilley's monumentality, Freud commented: 'Initially being very aware of all kinds of spectacular things to do with her size, like amazing craters and things one's never seen before, my eye was naturally drawn round the sores and chafes made by the weight and head.'[27] But in works such as *Sleeping by the Lion Carpet* 1996 he treats her with the dignity Velázquez had

40
Nude with Leg Up
1992
Oil paint on linen
182.9 × 228.6
Hirshhorn Museum and
Sculpture Garden, Smithsonian
Institution, Washington
DC, Joseph H. Hirshhorn
Purchase Fund, 1993

41
Naked Man, Back View
1991–2
Oil paint on canvas
183 × 137.2
Metropolitan Museum of
Art, New York. Purchase,
Lila Acheson Wallace
Gift, 1993 (1993.71)

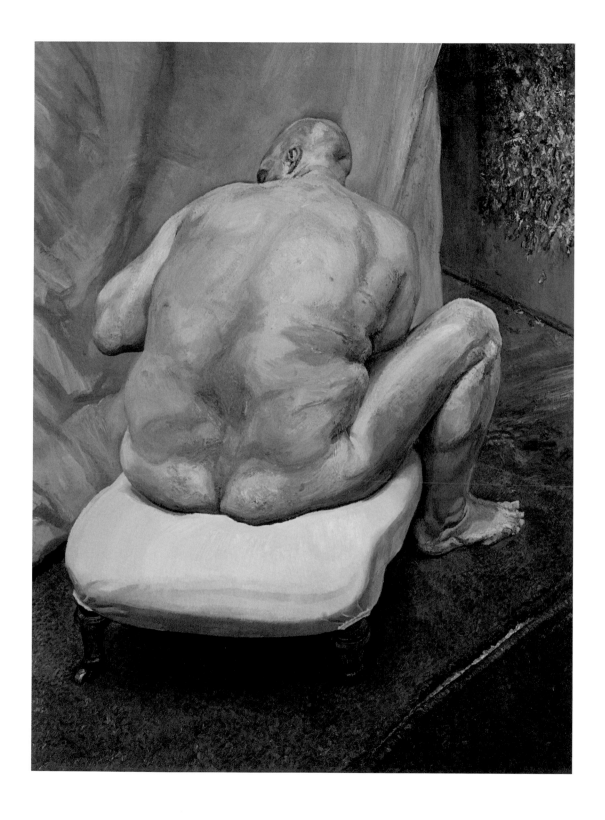

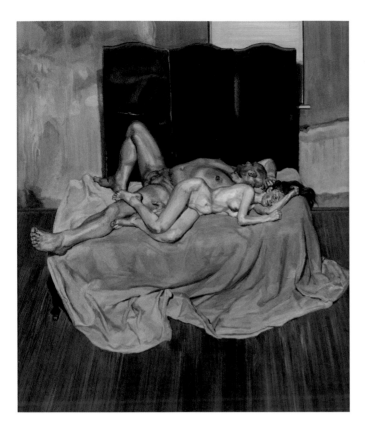 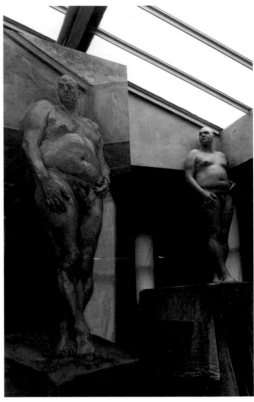

accorded sitters deviating from the norm. She appears against the backdrop of an exotic scene, perhaps dreaming of being a pearlescent, Titian-esque goddess, yet clearly happy in her own skin (fig.44).[28]

A number of writers have noted a fantastical quality in Freud's naked portraits of the early 1990s, with grotesque bodies and extreme poses suggesting a 'carnivalesque' world turned on its head.[29] If one compares Freud's paintings of Bowery and Tilley with their photographs, it seems he has slightly exaggerated their obesity and the looseness of their flesh (fig.43). For David Allan Mellor these works place Freud in a tradition of 'grotesque realism', a 'materialism of the belly' as described by Mikhail Bakhtin (1895–1975) in the 1940s, and in the context of the performance and body art scene emerging as a London subculture at this time.[30]

The naked portraits resonated with a revival of interest in painting during these decades that was promoted by some high-profile exhibitions – notably *A New Spirit in Painting* at the Royal Academy of Arts, London, in 1981.

42

And the Bridegroom
1993
Oil paint on canvas
232 × 196.2
Lewis Collection

43

Bruce Bernard , Leigh Bowery posing for **Leigh under the Skylight**, 1994

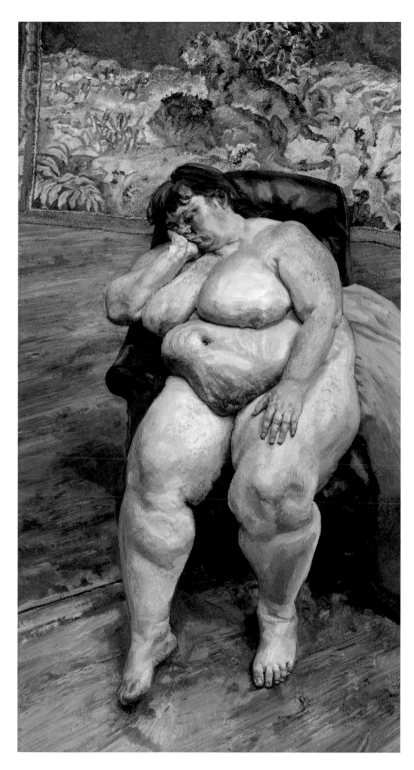

44
Sleeping by the Lion Carpet
1996
Oil paint on canvas
228 × 221
Lewis Collection

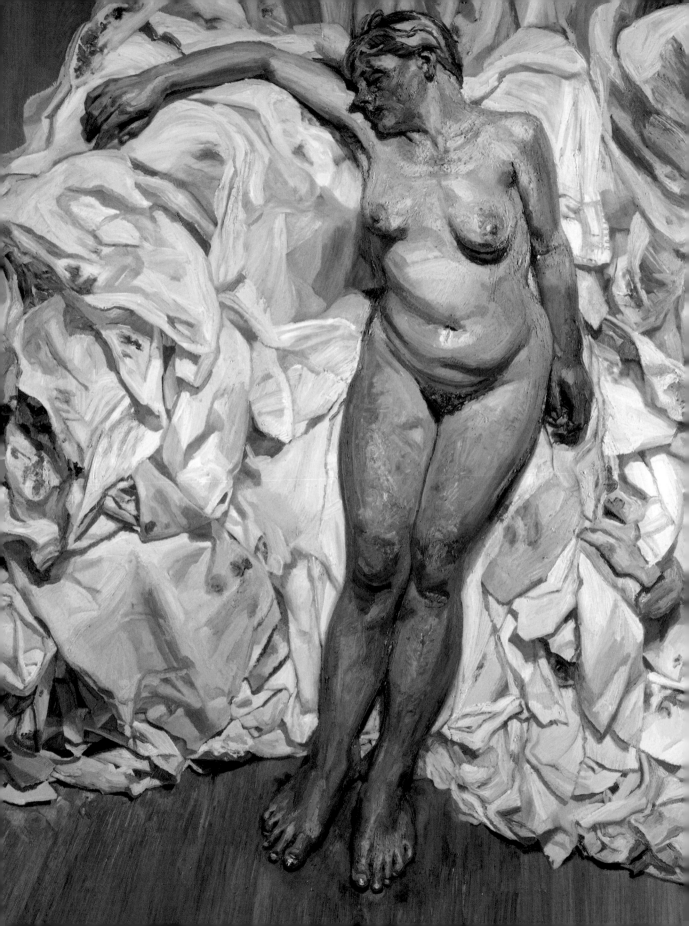

Painting was re-evaluated as an authored activity, pre-eminently connected with the human touch, in reaction to the perceived sterility of the then dominant international conceptual and minimal art movements. On the occasion of Freud's first retrospective in America, Hughes presented the case for his contemporary significance against the backdrop of the 1980s, with its all-pervasive mass media culture and ironic, postmodern recycling of existing styles in painting, as evidenced by voguish, mannered expressionism. Hughes argued for painting as a sublime 'dissent from visual orthodoxy', a somatic practice embracing specific, lived experience in the world, concluding:

> We are never loose from our bodies and the re-embodiment of our experience of that world – its delivery from the merely conceptual, the unfelt, the second-hand or the rhetorically transcendent – is what painting offers. Hence the present interest (belated enough but better late than never) in the work of Lucian Freud.[31]

Nevertheless, the ideological and corrective imperatives underpinning feminist reactions to Freud's work in the 1980s and 1990s probably made it difficult for his paintings to be seen through anything other than this lens during this period. His authoritative male champions, such as Hughes, were pitted against a rising tide of justifiable feminist discontent with the old art history, which Freud seemed to epitomise. Yet it is also possible to consider Freud's fleshy, shameless women as pro-feminist, particularly in the context of the strident body-beautiful culture that took hold during those decades, with its lycra-clad body-sculpting and rapidly developing cosmetic surgery, normalised by celebrities such as Jane Fonda, Madonna, and Ivana Trump.[32]

45
Standing by the Rags
1988–9
Oil paint on canvas
168.9 × 138.4
Tate. Purchased with
assistance from the
Art Fund, the Friends
of the Tate Gallery and
anonymous donors, 1990

A new idea of humanity was emerging through developments in genetic engineering and biotechnology that questioned the authenticity of the natural body and its relation to personality. While Freud's hankering to express a unified presence or identity, a biological and psychological truth, was superseded by postmodern notions of the divided, fragmented self, his attentive representations of drooping breasts, pitted thighs and folds of skin, resisted this vision of artificial physical perfection and continual self-reinvention (fig.45). As celebrations of human uniqueness, and of body and mind as whole, the naked portraits continue to defy our brave new world of the conceptual, provisional self. Breaking through our fevered dreams of immortality, now manifest in 'life extension' and cyber-technology, the naked portraits remind us of our animal selves and of our shared mortality.

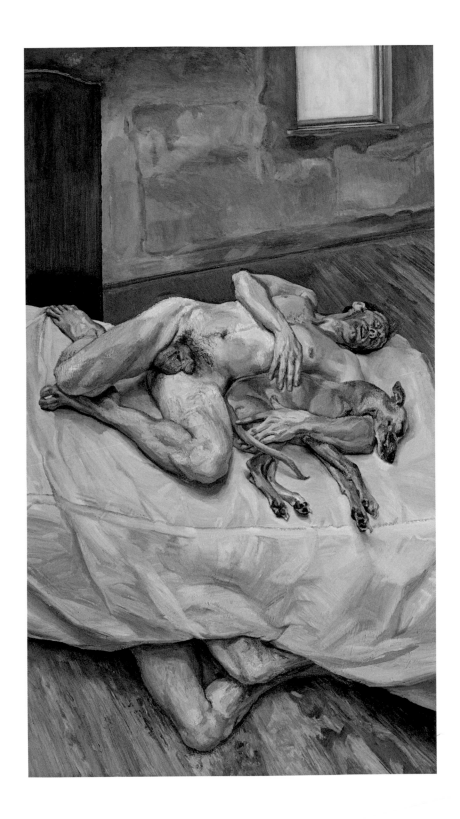

6 THE ARTIST'S EYE: FREUD AND THE OLD MASTERS (FROM THE 1980s)

All artistic discoveries are discoveries not of likenesses but of equivalences which enable us to see reality in terms of an image and image in terms of reality.[1]

IN 1987 FREUD WAS INVITED to select work from London's National Gallery collection for *The Artist's Eye*, an exhibition in a series exploring the relationship of contemporary artists with the past. Commenting in the catalogue, he revealed the centrality of the old masters to his practice, providing both benchmark and inspiration: 'What do I ask of a painting? I ask it to astonish, disturb, seduce, convince. One quality these paintings share is that they all make me want to go back to work.'[2] Expanding on Robert Hughes's convincing alignment of Freud with a nineteenth-century tradition of realism, curators have increasingly contextualised his work alongside historic collections, for example, at the Dulwich Picture Gallery (1994) and the Wallace Collection (2004) in London. Demonstrating Freud's immersion in art history, such exhibitions have identified Freud as a contemporary old master.

The Artist's Eye confirmed Freud's predilection for northern European art and nineteenth-century artists. However, his wide-ranging dialogue with the art of the past was more comprehensively explored in an exhibition at Vienna's Kunsthistorisches Museum in 2013, which Freud was involved in selecting. Positioning his painting adjacent to some of the greats he held in high esteem, the show highlighted the depth and breadth o

dialogue with the past, a consistent thread through his work over sixty years. But the emphasis of this and other such exhibitions has been on his affinity with individual artists rather than on 'art history' per se, particularly with Velázquez, Courbet, Titian and those artists – Watteau, Chardin, Constable and Cézanne – whose work he tackled through directly reworking specific images.

This chapter considers Freud's relationship to tradition in his picture-making, and how for him this came to justify his contribution to the existing world of pictures. Freud's status as a realist painter is not in doubt, but it seems important to qualify his relationship to that particular tradition. As Sebastian Smee has suggested, Freud's realism was less about knowing the world – the positivist impetus that drove nineteenth-century realism – and more about recognising its unknowability: 'Freud's painting is subtly different. It is predicated on a form of truth-telling which makes room for the honesty of not-knowing. And this is one of the ways in which he turned 19th-century realism on its head.'[3] Also, while averse to style or mannerism, Freud nevertheless elaborated and enriched his realism in ways that define his pictorial innovation and distinctiveness. This set his work apart from the cut-and-paste paraphrasing that has characterised much postmodern culture since the 1980s, arguably an era overwhelmed by the weight of the past and disenchanted with the idea of invention.

As he grew older, Freud's focus shifted from the intensely autobiographical to themes that more self-consciously questioned art itself. With the old masters as his reference, he allowed his realism to be nuanced with the visual language of the Rococo or Baroque to enhance a sense of feeling or drama, as he suggested in 2012: 'I have always been interested in bringing a certain kind of drama to portraiture, the kind of drama that I have found in paintings of the past. If a painting doesn't have drama, it doesn't work. It is just paint out of the tube.'[4] For example, *Sunny Morning – Eight Legs* 1997 (fig.46) shows his assistant David Dawson lying naked on a bed, accompanied by the artist's dog Pluto. Dawson's legs also appear inexplicably from under the bed, an idea perhaps suggested to Freud by the reflection of Actaeon's legs in a pool in Titian's *The Death of Actaeon* c.1565–75 in the National Gallery, London.[5]

Freud was as attentive to the particularities of certain old masters as he was to the naked model. In 1992 in a rare interview he spoke freely about

47
After Chardin (Large)
1999
Oil paint on canvas
52.7 × 61
Private collection

48
After Chardin
2000
Etching
77.2 × 96.5 (sheet),
59.6 × 73.4 (plate)
Edition 46 with 12
artist's proofs
Matthew Marks
Gallery, New York

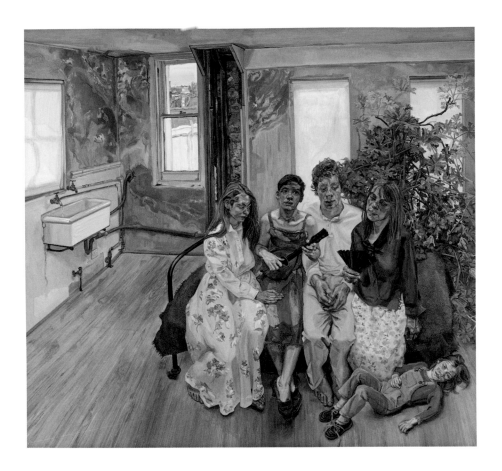

the ways in which certain old masters had informed his mark-making. For example, he admired Ingres's ability to convey information about his subject with apparent ease: 'You get really excited about an Ingres fold because you didn't think that so much could be said in such an incisive and economical way.' He also admired Ingres's ability to distort the figure while convincing the viewer of its naturalness. Another favourite had always been Hals, who with Velázquez inspired Freud's engagement with paint in the 1950s: 'I love Hals … His amazingly fluid and immediate way of painting, his sense of life which was absolutely fraught with warmth and feeling. When people talk about his vulgarity they are really talking about his vitality, an element that time hasn't been able to kill off. They still shock people very much.'[6] Familiar with Velázquez since his first visit to the Prado in 1952, later revealed: 'I believe in Velázquez more completely than any other whose work is alive for me. I understand Ortega y Gasset's strange ark on first seeing Las Meninas: "This isn't art, it's life perpetuated."'[7]

49

Large Interior W11 (after Watteau)

1981–3

Oil paint on canvas

186 × 198

Private collection

2

Another artist important to Freud for his precision and focus on specificity was the still-life and portrait painter Jean-Baptiste-Siméon Chardin (1699–1779). In 1999 Freud he was commissioned to respond to a work in the National Gallery for an exhibition *Encounters: New Art from Old* (2000). Selecting Chardin's *La Jeune Maitresse d'école (The Young Schoolmistress)* 1735–6, he worked in situ and produced four versions over several months in oils and etching. In the two oil versions Freud intensified what he perceived as the tenderness of the relationship between the girl and her young pupil, noting that 'Chardin painted here the most beautiful ear in art', while through subtle changes in physiognomic detail the larger oil version and etching suggest the difficulty of the lesson (figs 47–8).[8]

Freud absorbed the art of the past throughout his career, but in his mature decades – like other School of London painters – he produced a number of direct reworkings of pictures by old masters he admired. The first of this type was *Large Interior W11 (After Watteau)* 1981–3 (fig.49), based on Jean-Antoine Watteau's *Pierrot Content* c.1712 (Museo Thyssen-Bornemisza, Madrid), a group composition of commedia dell'arte characters in which two women compete for the affections of the central protagonist Pierrot. Freud referred to this modest, foot-square work in a commissioned portrait of its owner Baron Thyssen-Bornemisza, while working on his own enlarged version on a scale probably inspired by an exhibition he had seen of Courbet's paintings in 1978. It was immediately recognised as a new departure in his oeuvre. Freud reimagined Watteau's romantic, garden scene in the context of his run-down urban studio, his sitters depicted not with the graceful gestures of theatrical convention but, in the words of Robert Hughes, 'jostled together like a family in an amateur photograph'. As if declaring his own 'mistrust of theatre',[9] he replaced the charming narrative of the original with the awkwardly realistic boredom of posing over time. As Freud told Robert Hughes:

> For the first time in my life the individuals were secondary to the plan of the painting. I got them to look at the Watteau; and told them the idea of reworking it; and said I wanted a similar composition. I didn't want period costume, but I wanted variety in the clothes, and that they could dress up a little bit. The child on the ground has nothing to do with the Watteau. I needed her there to break the Watteau composition.[10]

Intended to show people 'rehearsing themselves as themselves', *Large Interior* suggested a more serious dialogue with the old masters in terms of interrogating painting itself:

I always felt that my work hadn't much to do with art; my admirations for other art had very little room to show themselves in my work because I hoped that if I concentrated enough the intensity of scrutiny alone would force life into the pictures. I ignored the fact that art, after all, derives from art. Now I realise this is the case.[11]

Dressing up a sitter – knowingly flaunting the artificiality of assumed disguises – was a well-established strategy within the realist tradition. Freud enjoyed, for example, the way that Velázquez had played with this convention in *Mars, God of War* 1640 (Museo del Prado, Madrid) to emphasise the truthfulness of his subject, telling John Richardson in 1993: 'I love his sadness and jokiness and the pointlessness of his strength. He's no god of war. He's a movie extra who might get a walk-on part as Mars.'[12]

Some of Freud's affinities were not initially obvious, an example being his love of John Constable (1776–1837), renowned as a landscape painter rather than as a painter of the human figure. Freud nevertheless admired the immediacy of Constable's brushwork and attachment to place, which conveyed genuine feeling and for Freud was tantamount to landscape as a form of portraiture. On seeing Constable's *Study of the Trunk of an Elm Tree* c.1821 (Victoria and Albert Museum, London) as a student, he had unsuccessfully attempted to paint his own close-up of bark. Some fifty years later he painted *Naked Portrait Standing* 1999–2001, deliberately reworking Constable's tree trunk as the trunk of a woman, arms behind her back and painted at close range to enhance the trunk-like verticality of her body (fig.50). While observing his model, he consciously did so through the lens of Constable's image, which had lived with him, perhaps unconsciously, over many years. He later made his own copy of the Constable in an etching, *After Constable's Elm* 2003.

In 2000 Freud completed *After Cézanne* (fig.52), an enlarged version of Cézanne's small post-coital brothel scene *L'Après-midi á Naples (Afternoon in Naples)* 1872–5 (National Gallery of Australia, Canberra), which he bought from a Sotheby's sale. The three protagonists in Cézanne's picture – man, prostitute, servant – are transposed on a grand scale, acting out the melodramatic scene on the familiarly austere, low-rent stage of Freud's studio. The painting retains the farcical scenario depicted by Cézanne, but the nakedness of Freud's servant and the detachment of the male model (his son Freddy) sets up a narrative tension absent in the

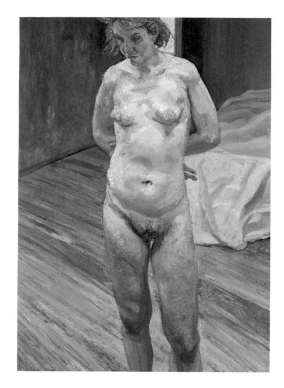

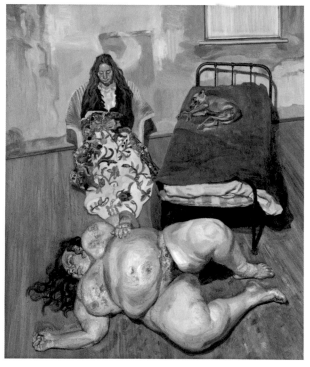

50
Naked Portrait Standing
1999–2001
Oil paint on canvas
109.2 × 77.5
Private collection

51
Evening in the Studio
1993
Oil paint on canvas
200 × 169
Lewis Collection

original, a strange 'psychological climate' also felt in earlier works such as *Large Interior W9* 1973 and *Evening in the Studio* 1993 (fig.51).[13]

Dialogue with the past had been central to art practice since the Renaissance, and had been perpetuated by the great exponents of modernism known personally to Freud, such as Picasso, whose entire oeuvre might be seen in terms of its conscious rivalry with tradition. Freud's thinking about tradition was formed in the 1940s, when a generation of emerging British artists was weighed down by expectation, overshadowed by past achievements, as the reputations of Turner, Constable and William Blake were revived and celebrated. From early on Freud aligned himself to tradition, but – encouraged by Giacometti's example – he resolved not to be stifled by it. Moreover, he felt the seemingly unanswerable attack on tradition by Marcel Duchamp (1887–1968) as a personal challenge to create something that mattered.[14]

Freud's understanding of his relationship to tradition might also be considered within the intellectual framework provided by influential art historian and Austrian émigré E.H. Gombrich (1909–2001), whose seminal *Art and Illusion: A Study in the Psychology of Pictorial Representation* (first delivered

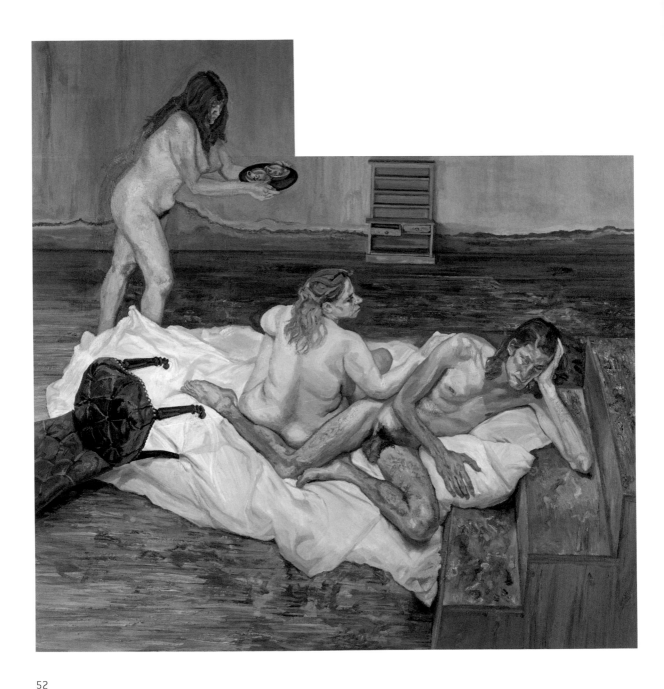

52

After Cézanne
2000
Oil paint on canvas
14 × 215

National Gallery of Australia,
Canberra. Purchased with
the assistance of Members
of the NGA Foundation,

including David Coe,
Harold Mitchell AO, Bevelly
Mitchell, John Schaeffer
and Kerry Stokes AO 2001

as Mellon Lectures in Washington in 1956, published 1960) changed the way art history was perceived. Gombrich belonged to Vienna's cultural elite and his family was connected to Sigmund Freud. As a young art historian, Gombrich worked for the museum curator and psychoanalyst Ernst Kris (1900–1957), who was his friend, collaborator and one of Sigmund Freud's protégés. Kris helped Gombrich move to London in 1936. While Lucian Freud was receptive to ideas from many sources and constantly reassessed his perceptions of the world, it seems likely that his understanding of image-making (how he rationalised his practice of art) was to some extent rooted in the great Viennese theorists stimulated by, and in the orbit of, his illustrious grandfather.[15]

In *Art and Illusion* Gombrich explained how art influences our perception of reality and vice versa. Contradicting John Ruskin's idea of the 'innocent eye', he proposed that reality is perceived through a legacy of inherited 'schemata'. Through observing the natural world, an artist gradually 'corrects' or makes adjustment to these pictorial schemata, inventing a new vision. In the same way the viewer brings a stock of residual images – from art and the natural world – to bear on his or her understanding of a picture. This had the effect of demystifying art, as on one level artists were simply visually problem solving.[16] Drawing on theorists such as his friend Karl Popper (1902–1994), Alois Riegl (1858–1905) and on the emergent science of psychology, Gombrich convincingly proposed that seeing and depiction are shaped by experience, practice and attitudes.

Like Freud, Gombrich was sceptical of 'vanguardism' – modernism as the pursuit of novelty. He abhorred the consensus view held in the post-war years that figuration had been superseded by abstraction. Despite his theoretical sophistication, ultimately Gombrich believed in the evolution of art (in innovation as an evolution of tradition) and in its continuing power to enthral and to reveal truth. As Christopher S. Wood has written: 'Gombrich cannot disguise his excitement about the image that manages somehow to seize the real. That shines through *Art and Illusion*'s screen of explanations.'[17] Freud's own passionate belief in the truth-telling power of art may well have been reinforced by Gombrich's assertion that we react to visual depictions in much the same way that we react to the actual object, the painting stimulating the same perceptual responses.[18]

'I am a biologist', Freud stated, explaining his intense curiosity about all living things – animals and plants, as well as human subjects. It was an

approach he felt he had inherited from his grandfather, who had been
dubbed a 'biologist of the mind'.[19] Gombrich's theory of the psychology
of perception was also grounded in the physical, in biological animal
responses. In 1971 he wrote in a letter:

> I think the main difference between my approach and that of the
> positivist philosophers is due to a very important divergence. They all
> ultimately derived from the English empiricists ... My initial 'schema'
> is (I believe) biological. I don't think in terms of 'the mind' and 'ideas' or
> their associations, I don't ask what the content of consciousness is at any
> time, I am interested in the reactions of the organism ... What enters
> our awareness or consciousness is our reaction, not our 'impression'.[20]

In 2002, as selector of an exhibition of Constable's work for the British
Council and Grand Palais, Paris, Freud observed: 'For me Constable is
so much more moving than Turner because you feel, for him, it's truth-
telling about the land rather than using the land for compositions which
suited his inventiveness.' William Feaver also insisted that Freud's choice
of works had been guided as much by his admiration for Constable's
directness and authenticity as his wish to emphasise that 'originality in
art stems not from novelty, but from innovation'.[21] Clearly, Freud shared
Gombrich's view that Constable had successfully shed the overwhelming
influence of culturally learnt 'schemata'.

For Freud innovation meant adding meaningfully and inventively to an
existing tradition rather than creating something new that, without roots,
could be dismissed as a passing fad. His work retained an existential edge,
yet was sustained by a belief in the continuity of art. When Freud looked at
work of the old masters, he analysed how an image had been made from the
painter's perspective, bringing him closer to an apprehension of the artist's
eye and an understanding of their adjustments to nature. For Freud, like
Gombrich, there was no history of art, only artists.[22] Freud was criticised
for pretending that a direct and privileged relationship existed between
what he saw and felt and the marks on his canvas. Perhaps for him this was
no pretence but commensurate with his understanding of how art is made,
a visual language learnt and reworked through the individual eye.[23]

7 TIME AND REALITY: FREUD'S SIGNIFICANCE AND LEGACY

The consummate artist conjures up the image of a human being that will live on the richness of its emotional texture when the sitter and his vanities have long been forgotten.[1]

DRAWING ON THE THEMES introduced previously, this concluding chapter explores the notion of time in Freud's paintings, played out in both the form and content of his work. For Freud the specificity of the 'real' body as lived experience – contingent, and particular to time and place – supported rather than contradicted its transcendence. For him the human subject could communicate across time:

> I think the most boring thing you can say about a work of art is that it's 'timeless'. That induces a kind of panic in me. It's almost like political speech – it doesn't apply to anyone. The idea that something's wrong if the work gives off a feeling of being tied to the moment is crazy. One of the things about great art is that it involves you, don't you agree?[2]

While intensely cultured and well read, Freud was committed to the power of the image as a silent, tacit language, but a language more eloquent than words in its potential to disarm, to tell the truth. Freud's naked portraits aligned his work to the tradition of *nature morte*, yet through this unsentimental rendering of the human condition, he hoped to connect across the centuries. He sought not to create a 'timeless' image, but one that was so specific, so real, it would through sheer force of its particularity, of

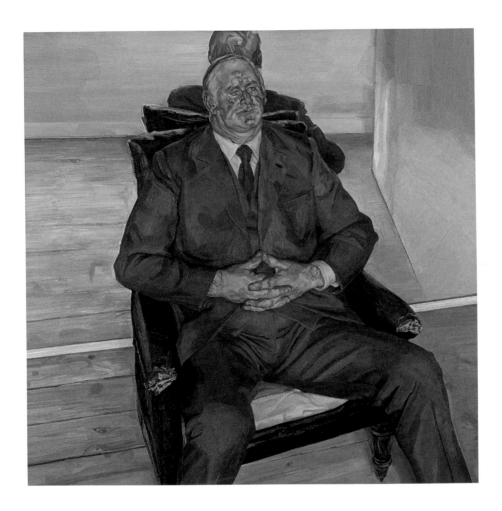

the time spent between himself and the model in the studio, be recognised at some very deep level as conveying a timeless human truth.

With extraordinary dedication, he painted the evolving life of the studio, a 'continuous group portrait' of people and things moving in and out of the same intimate spaces over a lifetime.[3] Like artists before him, notably Velázquez, Courbet and Picasso, he foregrounded the life of the studio, the site and iconography of painting itself, partly as a defiant gesture against the politicisation of art. But in focusing on the apparently artificial life of the studio, Freud was able to convincingly portray a continuous sense of time passing, reminding us perhaps of the influential proposition of Henri Bergson (1859–1941) that time cannot be apprehended by science or maths, but is experienced subjectively or intuitively as duration. Freud's subjects

53
The Big Man
1976–7
Oil paint on canvas
91.4 × 91.4
Private collection

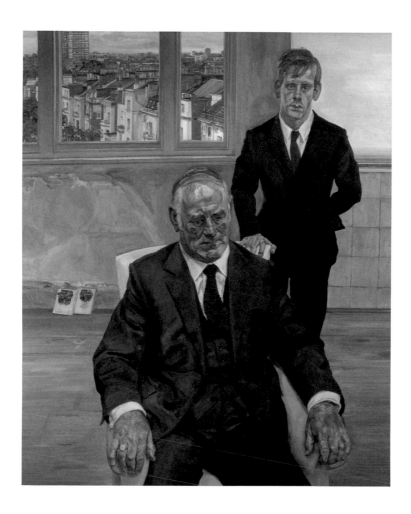

54
Two Irishmen in W11
1984–5
Oil paint on canvas
172.7 × 142.2
Private collection

– friends, family, other sitters, as well as Freud himself – age over time. For example, *The Big Man* 1976–7 (fig.53), an Irish trader and friend of the artist, makes several appearances in paintings alone or with his son, as in *Two Irishmen in W11* 1984–5 (fig.54). His son later crops up with his younger brother in *Two Brothers from Ulster* 2001 (private collection), his teenage frame considerably bulked out.

Freud's fascination with naturalism as a touchstone for communicating human existence across time is indicated by his declared longstanding interest in the Egyptian Amarna heads reproduced in James Henry Breasted's *Geschichte Aegyptens* (*History of Egypt*). Freud was pointedly photographed in this studio with the book in 1989, and the fact that he painted it on several occasions as a still life in the early 1990s suggests that

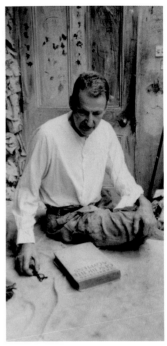

it might be seen almost as a visual manifesto (fig.55). These works feature two particular photographs, selected from the lavishly illustrated 1936 edition given to him by Peter Watson in 1939, showing Romano-Egyptian encaustic paintings (AD100) from Faiyum, originally produced like masks to adorn mummies (fig.56).[4] Two fragmentary self-portraits echoing these heads appear propped against the wall in the background of *Two Irishmen in W11*, transforming the commissioned double portrait into a *vanitas*, or *memento mori*. Reminding us that wealth and riches cannot prevent the inevitability of death, the vivid realism of the Egyptian masks also suggests the continuity of human life.

Although his portraits were sometimes condemned as morbid or cruel, Freud believed a sense of mortality or 'poison' was essential for good art, as he revealed when commenting on Titian's work: 'They have what every good picture has to have, which is a bit of poison. In the case of a painting … it might take the form of an attitude. A sense of mortality could be the poison in a picture, as it is in these.'[5] Freud's deliberate allusion to mortality is most obvious in his subject matter, with its emphasis on the vicissitudes of the flesh, the decomposition of plants and the mouldering, worn-out decor of the studio (fig.57). But it is also signified by the painfully

55
Still Life with Book
1993
Oil paint on canvas
45.75 × 51
Private collection

56
Lucian Freud with his
copy of J.H. Breasted's
History of Egypt, c.1989
Photograph by
Julia Auerbach

57

Two Plants

1977–80

Oil paint on canvas

149.9 × 120

Tate. Purchased from

Anthony d'Offay Ltd

(Grant-in-Aid) 1980

evident labour that has gone into the work, in his handling of the paint itself, which Gowing noted in 1982 as Freud's sense of 'painting in time'.[6]

Freud's process was arduous, his concentration and stamina legendary, his paintings developing from the centre outwards through laborious accumulations. He wiped his brush clean after each stroke, intent, like Cézanne, on making every mark count. In common with Bacon, Auerbach and Kossoff, he believed in the power of paint to tell more about a living subject than a photograph or film. Freud's models appear immobile, but rather than capturing a single moment, their stillness represents the holding of a pose over long periods of time – it embodies duration. A sense of time is also suggested by the absence of a single viewpoint, which would allow the image to be taken in at once. Instead, the viewer's eye feels its way around the image, guided by the brushmarks and passages of paint building time into the process of looking and, in doing so, reflecting Freud's own prolonged and intense observation of the subject.

The French phenomenologist Maurice Merleau-Ponty proposed that vision is actively affected by the object in a sensory feedback loop, so that the painter and the subject are both looking and looked at. This reciprocity

chimes with Freud's insistence on empathy with his subject and makes these portraits as much about himself as his sitters.[7] They also remind us of E.H. Gombrich's argument – with which Freud was no doubt familiar – that 'no stationary view can give us complete information'.[8]

Writers on Freud have commented on the sense of 'frozen' or arrested time that pervades many works across his oeuvre. David Alan Mellor, for example, has specifically linked Freud's early portraits to the idea expressed by philosopher Emmanuel Lévinas (1906–95) of the human face as existing outside of history, time and space: 'Just as Freud wishes to stand outside time, so Lévinas considered that the experience of the proximity of the other's face radically disturbed temporality.'[9] Lévinas called this interruption of time 'the event of transcendence'. In 'Time and the Other', a series of influential lectures delivered in Paris in the late 1940s, he began to express his idea of the ethical responsibility we have towards the Other as the only possible escape from isolation. All our efforts of self-sufficiency, mastery and control are flawed, because individual subjectivity is formed through reciprocity with someone else, a fact only fully realised in our encounter with the vulnerable face of the Other. For Lévinas the Other also makes the world 'real', the presence of the Other offers proof that the world is not an illusion. As an individual, Freud craved emotional engagement yet felt acutely the pressure of others in his life, as he wrote in 1954: 'All the pleasures are solitary. I hate being watched at work. I can't even read when others are about.'[10] This tension between the self and the other appears to be accentuated in Freud's approach to his human subjects.

Assessing Freud's process of painting a sitter, Rolf Lauter has referred to a Bergsonian sense of 'intensive duration'. For Lauter the protracted sittings endured by models, together with their spatial isolation, allowed Freud 'to gaze deep into them and to a certain extent to reveal their innermost self for the viewer to perceive'.[11] Another, less essentialist way of putting this would be that the artist sees the body, which can write on the skin from the inside, under duress and over time, the skin revealing states of mind or personality traits.[12]

Freud never replaced the tops on tubes of paint, instead wiping their crusting surfaces on his wall, which over time documented his daily habit. From the 1990s these paint walls appear as a motif in his paintings – amorphous organic forms in the background, a reminder of the process of

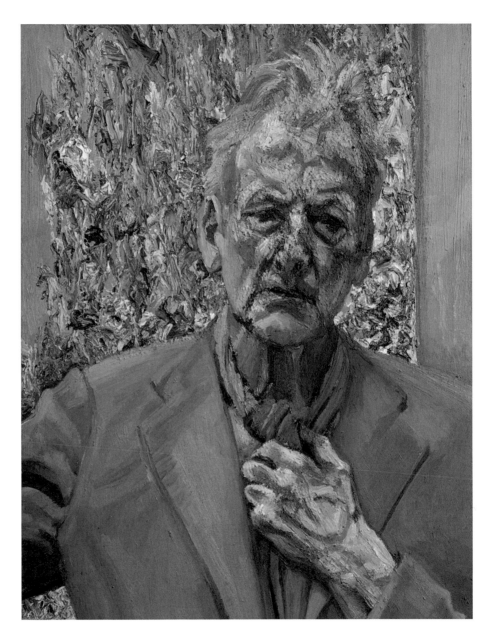

58

Self-Portrait, Reflection

2002

Oil paint on canvas

66 × 50.8

Private collection, courtesy of Acquavella Galleries

painting, like the mountains of studio rags used for cleaning his brushes. As Richard Shiff has noted: 'The configuration of the wall is itself without composition and ever changing, a living presence that grows: Freud's renderings, not only of the paint-wall but of everything else, possess this living quality.'[13] The encrusted paint on the wall in *Self-Portrait, Reflection* 2002 merges with the artist's hair, appearing indistinguishable from the paint marks representing his forehead, cheeks and nose (fig.58). In *Ib and her Husband* 1992 (fig.59) the daubs of paint seem to emanate from Freud's son-in-law's head like a dream depicted by Henry Fuseli (1741–1825).

Since the revival of interest in the self, identity and the other in the late twentieth century, many artists have been continuing to explore human subjectivity and reality, attracted to the base or abject visceral reality of flesh as a reaction to increasingly sanitised and homogenised images of (particularly female) bodily perfection – as, for example, in the work of Kiki Smith, Helen Chadwick (1953–1996) or Mona Hatoum. Postmodern ideas of the self (and the body) as fragmented and socially constructed were effectively represented through lens-based media, but painting was also reappraised as a medium for conveying the less visible aspects of the human condition. Freud's idea that a face and body could somehow reveal the essence of an individual personality, while dismissed by critical theorists in the 1970s and 1980s, now seems less at odds with current scientific thinking.[14] His relevance from the 1990s onwards should also be considered in the context of an ongoing debate about the 'internal' power of images and objects, as opposed to their signification purely within social or cultural contexts, the notion of images so vital that they can 'possess' the viewer.[15]

The relationship between paint and skin exploited by Freud, Bacon, Auerbach and Kossoff – both in tactile and metaphorical terms – had been central to the work of many earlier artists, from Titian to Willem de Kooning (1904–1997). A younger generation of British artists have responded to Freud's equation of the painted surface with skin, Jenny Saville and Cecily Brown among them. Emily Braun has noted the peculiarly British obsession with the inherent relationship between the properties of body and flesh, which she describes as 'skinning the flesh': 'Making the paint work as flesh, not like it, as Freud would have it, the canvas becomes a tactile, cutaneous surface, formed by layers of pigment subjected to peeling and surgical cuts and bearing all the organic traces of its making.'[16] A key aspect of this is the accumulation of marks recording

the complexity of vision, over time, as opposed to the photographic snapshot. Like Freud, Brown, in her explorations of gendered touch through painterly gesture, focuses on the human as animal, governed by biological impulses, destined to die. What draws the viewer into such paintings is not the illusion of reality but 'haptic vision' – the sense we have, through the material of paint, of the flesh as touched or felt, combining sight and tactility, a phenomenon identified by philosopher Gilles Deleuze in 1981 in relation to the work of Francis Bacon.[17] One feels the weight of Sue Tilley's head as it rests on her hand in Freud's *Sleeping by the Lion Carpet* 1996. Like Freud, Saville enhances this 'feeling of embodiment' in her paintings by representing bodies pressed together.[18]

Freud's themes might be seen echoed in the works of other young British artists, whose work focuses on conveying the sense of inhabiting a body, such as sculptures by Ron Mueck, or on personal subject matter rooted in the world of experience. Bacon and Freud's bohemian exploits, dandyism and celebration of London's urban culture have informed the self-made identities of artists such as Damien Hirst, whose shock art tactics evolved from an obsession with the *memento mori* and a desire to make works so memorable that they would make people believe in art. Like Freud, Hirst has more recently explored such themes in relation to the old masters. The gritty realism of diarism or confessional art with its emphasis on the often sordid details of human existence, as exemplified by the work of Tracey Emin, might also be seen in relation to Freud's candour and his disregard for societal norms of decency.

In 1988 Freud's iconic portrait of Francis Bacon of 1952 was stolen from an exhibition in Berlin while on loan from Tate. If Freud had lived to read Donna Tartt's novel *The Goldfinch* (2013), he might have taken some comfort from the parallels between the novel's stolen masterpiece, *The Goldfinch* 1654 by Carel Fabritius (1622–1654), and that of his similarly small but unforgettable work. In Tartt's narrative *The Goldfinch*, too famous to be sold, is circulated among criminals as collateral until finally liberated and restored to public ownership. Writing of the talismanic power exerted by the realistic rendering of a tethered bird, Tartt asserts a view of art that might have resonated with Freud:

> A really great painting is fluid enough to work its way into the mind and heart through all kinds of angles, in ways that are unique and very particular.

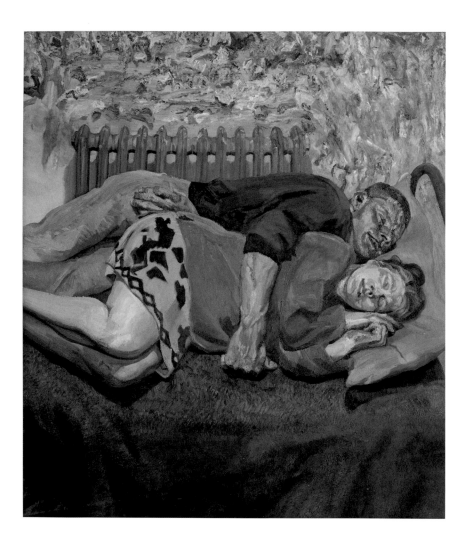

She concludes:

> And in the midst of our dying, as we … sink back ignominiously into the organic, it is a glory and a privilege to love what Death doesn't touch. For if disaster and oblivions have followed this painting down through time – so has love. It exists and it keeps on existing.[19]

Many would agree that Freud fully achieved his ambition to make art that mattered, like paintings of the past that he felt were 'so powerful that one cannot imagine how anyone could have made them, or how they could ever not have existed'.[20]

59
Ib and her Husband
1992
Oil paint on canvas
168 × 147
Private collection

NOTES

INTRODUCTION

1 The 'School of London' has been used broadly to describe representational art in London since the 1950s, and more specifically a group of artist friends who met regularly at Wheeler's fish restaurant in Soho in the early 1960s – Francis Bacon, Frank Auerbach, Leon Kossoff, Mike Andrews and Freud – as promoted by artist R.B. Kitaj in the Arts Council of Great Britain exhibition, *The Human Clay* (1976).

2 Sebastian Smee, *Lucian Freud 1996–2005*, London 2005, p.12.

3 John Rothenstein, *Modern English Painters, Volume 3: Wood to Hockney*, London 1974 (1976 impression), pp.196, 199.

4 In his essay 'The Painter of Modern Life' (first published 1863) Charles Baudelaire (1821–67) presented the *flâneur* as an artist-poet of the modern metropolis, a 'lover of life who makes the whole world his family'.

5 Marina Warner, 'Lucian Freud: The Unblinking Eye', *New York Times*, 4 Dec. 1988 (http:/nytimes.com/1988/12/04/magazine).

6 Lucian Freud, 'Some Thoughts on Painting', *Encounter*, vol.3, no.1, July 1954, pp.23–4.

COMMITMENT TO LOOKING (EARLY YEARS TO 1951)

1 Freud 1954, p.23.

2 Richard Calvocoressi, *Lucian Freud: Early Works*, exh. cat., Scottish National Gallery of Modern Art, Edinburgh 1997, pp.11–12.

3 Laurence Gowing, *Lucian Freud*, Thames and Hudson, London 1982, p.8.

4 Richard Morphet, *Cedric Morris*, exh. cat., Tate Gallery, London 1984, p.58.

5 James Hyman, *The Battle for Realism: Figurative Art in Britain during the Cold War 1945–1960*, New Haven

and London 2001, p.104.

6 Sebastian Smee, *Lucian Freud: Beholding the Animal*, Cologne 2012, p.17.

7 John Russell, *Lucian Freud*, exh. cat., Hayward Gallery, London 1974, p.7.

8 Gowing 1982, p.60.

9 David Alan Mellor, *Interpreting Lucian Freud*, London 2002, p.47.

10 Walter Benjamin, *A Short History of Photography* (1931) and *The Work of Art in the Age of Mechanical Reproduction* (1936).

11 Freud's parents owned reproductions of *The Hare* and *The Great Piece of Turf* by Dürer (Calvocoressi 1997, p.11).

12 Gowing 1982, p.60.

13 David Sylvester, 'Portrait of the Artist No.36: Lucian Freud', *Art News and Review*, 17 June 1950.

14 Herbert Read, *Contemporary British Art*, Harmondsworth 1951 (rev. 1964), p.35.

15 Mellor 2002, p.23.

16 William Feaver, *Lucian Freud*, exh. cat., Tate Britain, London 2002, p.25.

17 Gowing 1982, p.19.

18 Sylvester 1950.

COMMITMENT TO PAINTING (1952 TO MID-1960s)

1 Lucian Freud, 'Art Scene, Private View', *Tatler*, March 2004.

2 'Frank Auerbach on Lucian Freud' in William Feaver, *Lucian Freud*, exh. cat., Tate Britain, London 2002, p.51.

3 Freud quoted in William Feaver, 'Freud at the Correr: Fifty Years', *Lucian Freud*, exh. cat., Museo Correr, Venice 2005, p.34.

4 James Hyman, *The Battle for Realism: Figurative Art in Britain during the Cold War 1945–1960*, New Haven and London 2001, pp.4, 110.

5 William Feaver, 'The Artist out of his Cage: William Feaver Interviews Lucian Freud', *Observer Review*, 6 Dec. 1992, pp.45–6.

6 Robert Hughes, *Lucian Freud Paintings*, exh.

cat., Hirshhorn Museum, Washington DC 1987, p.7.

7 Mellor 2002, pp.52–3, and Caroline Blackwood in *Lucian Freud, Early Works*, exh. cat., Robert Miller Gallery, New York 1993, p.16.

8 Mellor 2002, pp.55–6. Margaret Garlake also links Freud's attachment to the material world with A.J. Ayer's 'sensible world' of phenomenology in her *New Art New World: British Art in Postwar Society*, New Haven and London 1998, p.185.

9 Freud 1954.

10 Ibid. According to Sylvester in his role as arts editor of *Encounter*, Freud 'dictated' his 'thoughts' to him: see Hyman 2001, p.109.

11 Hyman 2001, p.110.

12 Freud 1954.

13 Hyman 2001, p.110; Feaver 2002, p.29.

14 Freud 1954. Sylvester wrote the Venice Biennale exhibition catalogue and reviewed the exhibition in *Encounter*.

15 Charles Baudelaire, quoted in *Baudelaire: Selected Writings on Art and Artists*, trans. P.E. Charvet, Cambridge 1981, p.421.

16 Freud 1954.

THE STUDIO: PROXIMITY AND REFLECTIVE DISTANCE (1960s–70s)

1 Freud quoted in Smee 2012, pp.37–8.

2 Wouter Davidts has questioned the extent of the 1960s' rejection of the studio in Wouter Davidts and Kim Paice (eds.), *The Fall of the Studio: Artists at Work*, Amsterdam 2009, pp.63–81.

3 Davidts and Paice 2009, pp.186–8.

4 Lucian Freud in Michael Peppiatt (ed.), *Modern Art in Britain* (*Cambridge Opinion*, no. 37), Cambridge 1963, p.47.

5 Freud quoted in William Feaver, *Lucian Freud*, New York 2007, p.33.

6 Michael Peppiatt and Frank Auerbach, 'Frank Auerbach: Going against the Grain',

Art International, no.1, Autumn 1987, pp.22–9.

7 Cécile Debray (ed.), *Lucian Freud: The Studio*, exh. cat., Centre Pompidou, Paris 2010, p.154.

8 Debray 2010, pp.154–8.

9 Freud quoted in Feaver 2002, p.47.

10 R.B. Kitaj, *The Human Clay*, exh. cat., Arts Council of Great Britain 1976.

11 David Sylvester, *Interviews with Francis Bacon*, London 1980, p.105.

12 *Eight Figurative Painters: Andrews, Auerbach, Bacon, Coldstream, Freud, George, Kossoff, Uglow*, exh. cat., Yale Center for British Art, New Haven, 1981, p.14.

13 Auerbach, quoted in Alistair Hicks, *The School of London: the Resurgence of Contemporary Painting*, Oxford 1989, p.28.

14 See David Cohen, 'Grand Living and Quirky Forms: Six Painters of the London School', in Richard Calvocoressi (ed.),*From London: Bacon, Freud, Kossoff, Andrews, Auerbach, Kitaj*, exh. cat., Scottish National Gallery of Modern Art, Edinburgh 1995, pp.15–37, esp. p.21.

15 Russell 1974, pp.23, 27.

16 Freud quoted in Laurence de Cars, 'Realist Echoes in Lucian Freud', Debray 2010, p.54.

17 Norman Bryson, *Vision and Painting: The Logic of the Gaze*, New Haven and London, 1983, p.93.

18 Freud revealed Seneb's tomb as a source in Nicholas Penny, 'Lucian Freud: Plants, Animals and Litter', *Burlington Magazine*, vol.130, April 1988, pp.290–5, esp. p.295.

19 Andrew Benjamin, *Art, Mimesis and the Avant-Garde: Aspects of a Philosophy of Difference*, London and New York 1993, p.71.

20 Benjamin 1993, p.68.

21 Sarah Howgate, *Lucian Freud Portraits*, exh. cat., National Portrait Gallery, London 2012, p.32.

22 Bryson 1983, pp.94, 121–2.

23 Mellor 2002, p.15.

24 Joanna Woodhall (ed.), *Portraiture: Facing the Subject*, Manchester and New York 1997, p.170.

25 http://en.wikipedia.org/ wiki/Mirror_stage.

26 Woodhall 1997, pp.12, 242.

27 Feaver 2002, pp.44–5.

28 Feaver (2002, p.31) notes that following his father's death Freud reworked the rubbish in *Wasteground with Houses, Paddington*, enhancing its visible decay,.

29 Ibid.

30 Feaver 2002, pp.31–2.

THE NAKED PORTRAIT (1980s ONWARDS)

1 'Lucian Freud in Conversation with Michael Auping', 9 Dec. 2009, in Howgate 2012, p.213.

2 Gowing 1982, pp.190–1.

3 John Richardson, 'Paint Becomes Flesh', *New Yorker*, 13 Dec. 1993, p.135.

4 He became more open about his work, trusting writers and curators, such as John Richardson, John Russell, William Feaver and Catherine Lampert.

5 Hughes 1987, p.21.

6 *Carnegie International*, exh. cat., Museum of Art, Carnegie Institute, Pittsburgh 1985, p.131. Sigmund was dubbed 'biologist of the mind' (Frank J. Sulloway, *Freud, Biologist of the Mind: Beyond the Psychoanalytic Legend*, New York and London 1979).

7 Hughes 1987, p.19.

8 Freud in conversation with William Feaver, *Third Ear*, BBC Radio 3, 10 Dec. 1991.

9 Freud 1954, p.24.

10 Gowing 1982, p.60.

11 Leon Kossoff quoted in Paul Moorhouse, *Leon Kossoff*, exh. cat., Tate Gallery, London 1996, p.36.

12 Rolf Lauter (ed.), *Lucian Freud: Naked Portraits: Works from the 1940s to the 1990s*, exh. cat., Museum für Moderne Kunst, Frankfurt am Main 2001, p.17.

13 Marina Warner, 'Lucian Freud: The Unblinking Eye', *New York Times*, 4 Dec. 1988 (http:/nytimes. com/1988/12/04/magazine).

14 Linda Nochlin, 'Frayed Freud', *Art Forum*, March 1994, pp.55–8, esp. p.56.

15 Warner 1988.

16 See Caroline Blackwood in 'Portraits by Freud', *New York Review of Books*, 16 Dec. 1993.

17 Freud quoted in William Fever, 'The Artist out of his Cage: William Feaver Interviews Lucian Freud', *Observer Review*, 6 Dec. 1992, pp.45–6.

18 David Cohen in Richard Calvocoressi and Philip Long (eds.), *From London: Bacon, Freud, Kossoff, Andrews, Auerbach, Kitaj*, exh. cat., Scottish National Gallery of Modern Art, Edinburgh 1995, pp.29–30.

19 Hughes 1987, p.20.

20 Feaver 2002, p.29.

21 Ellen Handler Spitz, 'Lucian Freud: Psychoanalysis in Paint?', *American Imago*, vol.67, no.3, Fall 2010, pp.441–50, esp. p.447.

22 Martin Fuller, 'The Naked and the Id', *Vanity Fair*, Nov. 1993 (http://www.vanityfair.com).

23 John Richardson, 'Lucian Freud and His Models', *Sacred Monsters, Sacred Masters*, London 2001, pp.322–41, esp. p.330.

24 See William Feaver, 'Beyond Feeling: Freud in conversation with Lucian Freud', *Lucian Freud*, exh. cat., Art Gallery of New South Wales, Sydney 1992.

25 Freud, quoted in William Feaver, 'Freud at the Correr: Fifty Years', exh. cat., Museo Correr, Venice 2005, p.37.

26 Alasdair Gray, 'Thoughts on Freud', *Modern Painters*, vol.6, no.4, 1993, pp.28–9, esp. p.29.

27 Feaver 1992.

28 Feaver 2002, p.45.

29 Mellor 2002, pp.23–4.

30 Mellor 2002, pp.30, 40.

31 Hughes 1987, pp.8–9.

32 See Jeffery Deitch, *Post-Human*, exh. cat., FAE Musée d'Art Contemporain, Pully/ Lausanne 1992, p.36.

THE ARTIST'S EYE: FREUD AND THE OLD MASTERS (1980s ONWARDS)

1 E.H. Gombrich, *Art and Illusion: A Study in the Psychology of Pictorial Representation*, London 1960, p.292.

2 Lucian Freud, *The Artist's Eye: Lucian Freud, An Exhibition of National Gallery Paintings Selected by the Artist*, exh. cat., National Gallery, London 1987, p.12.

3 Smee 2012, p.34.

4 'Lucian Freud in Conversation with Michael Auping', 7 Jan. 2011, in Howgate 2012, p.218.

5 Feaver 2002, p.46.

6 William Feaver, 'The Artist out of his Cage: William Feaver Interviews Lucian Freud', *Observer Review*, 6 Dec. 1992', pp.45–6.

7 Quoted in Xavier Bray 'I Believe in Velazquez: Lucian Freud and Spanish Art', in Sabine Haag and Jasper Sharp (eds.), *Lucian Freud*, exh. cat., Kunsthistorisches Museum, Vienna 2013, pp.44–7, esp. p.44.

8 *Encounters: New Art from Old*, exh. cat., National Gallery, London 2000, p.133.

9 Hughes 1987, p.24.

10 Hughes 1987, p.24.

11 Hughes 1987, p.14.

12 John Richardson, 'Paint Becomes Flesh', *New Yorker*, 13 Dec. 1993, p.143.

13 See Cécile Debray, 'Cézanne', in Debray 2010, pp.178–9.

14 Catherine Lampert, *Lucian Freud*, exh. cat., Irish Museum of Modern Art, Dublin, 2007, pp.46, 49.

15 The influence of Kris and Gombrich's book *Caricature* (Harmondsworth 1940) on Lucian Freud has been well documented.

16 Gombrich's proposition was widely influential until his naturalist approach was undermined by Norman Bryson who argued in *Vision and Painting: The Logic of the Gaze* (1983) that the picture was merely a coded message and representation is deceptive rhetoric. See Christopher S. Wood, 'Art History Reviewed VI: E.H. Gombrich's "Art and Illusion: A Study in the Psychology of Pictorial Representation", 1960', *Burlington Magazine*, vol.151, Dec. 2009, pp.836–9, esp. p.836.

17 Ibid., p.839.

18 Patrick Maynard, *Drawing Distinctions: The Varieties of Graphic Expression*, London 2005, p.97.

19 Veronika Kopecky, 'Letters to and from Ernst Gombrich regarding Art and Illusion, including some comments on his notion of "schema and correction"', https://arthistoriography.files.wordpress.com/2011/02/media_183172_en.pdf.

20 Sebastian Smee, Bruce Bernard, David Dawson, 'A Late-Night Conversation', *Freud at Work: Lucian Freud in Conversation with Sebastian Smee*, London 2006; and Jean Clair, 'Freud the Biologist', in Debray 2010, pp.44–51, esp. p.44.

21 Lucian Freud (with William Feaver), *Lucian Freud: On John Constable*, British Council 2003, pp.38, 7.

22 Gombrich opened *The Story of Art* (1950) with, 'There really is no such thing as art. There are only artists'.

23 Linda Nochlin, 'Frayed Freud', *Art Forum*, March 1994, pp.55–8, esp. p.58.

TIME AND REALITY: FREUD'S SIGNIFICANCE AND LEGACY

1 E.H. Gombrich, 'Portrait Painting and Portrait Photography', *Apropos*, no.5, 1945, p.6.

2 Freud quoted in Lucian Freud and Sebastian Smee, *Freud at Work: Photographs by Bruce Bernard and David Dawson*, London 2006, p.33.

3 'Freud in Conversation with Michael Auping', 9 Dec. 2009, in Howgate 2012, p.213.

4 A keen Egyptologist, Sigmund Freud also owned this book. He wrote *The Man Moses and Monotheistic Religion*, published posthumously in 1939, and owned a large collection of Egyptian objects; see Dietrich Wildung, 'Precedent Armana: Lucian Freud and Old Egypt', in Haag and Sharp 2013, pp.132–8, esp. p.133. Sigmund's collection also included several similar Faiyum paintings (Feaver 2002, p.48).

5 Martin Gayford, *Man with a Blue Scarf*, New York 2010, p.189.

6 Gowing 1982, p.161.

7 Richard Shiff, 'Painted Walls', in Debray 2010, p.64.

8 E.H. Gombrich, 'The "What" and the "How": Perspective Representation and the Phenomenal World', in R. Rudner and I. Scheffler (eds.), *Logic and Art: Essays in Honor of Nelson Goodman*, Indianapolis 1972, pp.129–49.

9 Mellor 2002, p.53, refers to Lévinas's *Otherwise than Being* (1974).

10 Freud 1954.

11 Rolf Lauter, 'Thoughts on Lucian Freud', in Lauter 2001, pp.29–66, esp pp.63, 66.

12 James Elkins, *Pictures of the Body: Pain and Metamorphosis*, Redwood City 1999, p.47.

13 Richard Shiff, 'Painted Walls', in Debray 2010, p.70.

14 See, for example, Roger Highfield et al., 'How your looks betray your personality', *New Scientist*, no.2695, 11 Feb. 2009 (http://www.newscientist.com).

15 See summary of this debate by Francis Frascina, 'Object/Self', *Art Monthly*, no.375, April 2014, pp.5–8.

16 Emily Braun, 'Skinning the Paint', Mark W. Scala (ed.), *Paint Made Flesh*, exh. cat., First Center for the Visual Arts, Vanderbilt University Press, Nashville, Tennessee 2009, pp.26–40, esp. p.29.

17 Gilles Deleuze, *Francis Bacon: The Logic of Sensation* (1981), trans. Daniel W. Smith, London 2003.

18 Braun 2009, p.35.

19 Donna Tartt, *The Goldfinch*, London 2013, pp.849–50, 864.

20 Freud quoted in Russell 1974, p.27.

CHRONOLOGY

1922
Lucian Michael Freud, born 8 December in Berlin, son of Ernst Freud (1892–1970) and Lucie Brasch (1856–1989), grandson of Sigmund Freud (1856–1939).

1933–7
Moves to England, 1933. Attends schools in Devon and Dorset.

1938–9
Studies at Central School of Arts and Crafts, London. In 1939 attends East Anglian School of Drawing and Painting, Dedham, Suffolk, and becomes a British subject.

1941–2
Merchant Navy (three months), 1941. Rejoins the East Anglian School, Benton End, Hadleigh, Suffolk. In 1942 moves to 14 Abercorn Place, St John's Wood, London; attends life-drawing classes at Goldsmiths College; and exhibits at Lefevre Gallery, London.

1943–5
Moves to Delamere Terrace, Paddington, 1943. Lefevre Gallery exhibition, 1944. Meets Francis Bacon (1909–1992), 1945.

1946
In Paris (two months) and meets Picasso (1881–1973), Giacometti (1901–1966) and Balthus (1908–2001). Stays with John Craxton (1922–2009) on Poros, Greece (five months), and exhibits at Lefevre Gallery.

1947–9
Exhibits at London Gallery. Visits Paris and south of France with Kitty Garman (1926–2011); they marry in 1948. Moves to 27 Clifton Hill, Maida Vale, London. Visiting Tutor, Slade School of Art (1949–54).

1951–3
Wins an Arts Council Prize at the Festival of Britain (1951). Rents rooms in Dublin with Kitty. In 1952 elopes to Paris with Lady Caroline Blackwood

(1931–1996); they marry in 1953. Exhibits at Hanover Gallery.

1954
Represents Britain at Venice Biennale. Writes 'Some Thoughts on Painting', *Encounter* (July).

1955–8
In 1955 meets Frank Auerbach (b.1931). Marriage with Caroline ends in 1957. Exhibits at Marlborough Fine Art, London, 1958.

1960–1
Visits Grünewald's Isenheim Altarpiece (Alsace), Musée Ingres (Montauban), Courbet's paintings (Montpellier), Goya's paintings (Castres).

1962–8
Moves to 124 Clarendon Crescent, Paddington, 1962, and visits Frans Hals exhibition, Haarlem, Netherlands. Exhibits at Marlborough Fine Art, 1963 and 1968. From 1964 Visiting Tutor, Norwich Art School. Lives at 227 Gloucester Terrace, Paddington (1965–72). In 1967 sees Ingres centennial exhibition (Petit Palais, Paris).

1972–6
Moves to 17 Thorngate Road, Maida Vale, 1972. First retrospective exhibition (Hayward Gallery, London, 1974). Exhibits in *The Human Clay* (Arts Council), 1976.

1977–81
Moves to Holland Park, retaining studio in Notting Hill Gate, 1977. Declines CBE. Shows in *The New Spirit in Painting* (Royal Academy, London), 1981.

1982–4
Monograph by Lawrence Gowing (1918–1991) published in 1982; made a Companion of Honour. Exhibits in *The Hard Won Image* (Tate Gallery, 1984).

1987–8
Selects *The Artist's Eye*, National Gallery, London, 1987. First major retrospective outside UK (British

Council, Hirshhorn Museum, Washington DC, touring to London, Paris and Berlin, 1987–8).

1990
Meets Australian performance artist Leigh Bowery (1961–1994). Painter-photographer David Dawson (b.1960) becomes his assistant.

1993–8
Awarded Order of Merit. Exhibits at Whitechapel Art Gallery, London, touring to New York and Madrid (1993–4). Exhibits at Dulwich Picture Gallery, London (1994); Abbot Hall Art Gallery, Kendall (1996); Scottish National Gallery of Modern Art, Edinburgh (1997); Tate Gallery (1998).

2001
Donates *Portrait of Her Majesty the Queen* (2000–1) to Royal Collection.

2002–10
Tate Britain retrospective (2002), touring to Barcelona and Los Angeles; selects Constable exhibition (Grand Palais, Paris, 2003); recent work at Wallace Collection, London (2004); retrospective at Museo Correr, Venice (2005); shows with Auerbach at Victoria and Albert Museum, London (2006); exhibits etchings at Museum of Modern Art, New York (2007–8); *Lucian Freud: L'Atelier*, at Centre Pompidou, Paris (2010).

2011
Dies on 20 July, aged eighty-eight.

SELECT BIBLIOGRAPHY

Bruce Bernard and Derek Birdsall (eds.), *Lucian Freud*, Jonathan Cape, London 1996

Richard Calvocoressi, *Early Works: Lucian Freud*, exh. cat., Scottish National Gallery of Modern Art, Edinburgh 1997

Cécile Debray (ed.), *Lucian Freud: The Studio*, exh. cat., Centre Pompidou, Paris 2010

William Feaver, *Lucian Freud*, exh. cat.,

Tate Britain, London 2002

William Feaver, *Lucian Freud*, New York 2007

Lucian Freud, 'Some Thoughts on Painting', *Encounter*, vol.3, no.1, July 1954, pp.23–4

Lucian Freud, *The Artist's Eye: Lucian Freud, An Exhibition of National Gallery Paintings Selected by the Artist*, exh. cat., National Gallery, London 1987

Lucian Freud (with William Feaver), *Lucian Freud: On John Constable*, exh. cat., Grand Palais, Paris 2003

Lucian Freud and Sebastian Smee, *Freud at Work: Photographs by Bruce Bernard and David Dawson*, London 2006

Lawrence Gowing, *Lucian Freud*, London 1982

Sabine Haag and Jasper Sharp (eds.), *Lucian Freud*, exh. cat., Kunsthistorisches Museum, Vienna 2013

Craig Hartley, *Lucian Freud: Etchings 1946–2004*, exh. cat., National Galleries of Scotland, Edinburgh, 2004

Sarah Howgate (ed.), *Lucian Freud Portraits*, exh. cat., National Portrait Gallery, London 2012

Robert Hughes, *Lucian Freud Paintings*, exh. cat., Hirshhorn Museum, Washington DC 1987

Catherine Lampert, *Lucian Freud: Recent Work*, exh. cat., Whitechapel Art Gallery, London 1993

Catherine Lampert, *Lucian Freud*, exh. cat., Irish Museum of Modern Art, Dublin 2007

Rolf Lauter (ed.), *Lucian Freud: Naked Portraits: Works from the 1940s to the 1990s*, exh. cat., Museum für Moderne Kunst, Frankfurt am Main 2001

David Alan Mellor, *Interpreting Lucian Freud*, London 2002

John Russell, *Lucian Freud*, exh. cat., Hayward Gallery, London 1974

Sebastian Smee, *Lucian Freud: Beholding the Animal*, Cologne 2012

ACKNOWLEDGEMENTS

I would like to thank all of those who have generously assisted me in writing this book, the idea for which was seeded some time ago following Lucian Freud's major retrospective at Tate Britain in 2002. As senior curator at Tate Britain until 2001, I worked closely with Lucian's longstanding friend, the critic and curator William Feaver, in the early stages of researching and planning the exhibition with the artist. I am especially indebted to Bill, who gave me a new appreciation of the work and introduced me to Lucian at that time. I am also grateful to Alice Chasey, my editor at Tate, who gave me the opportunity more than ten years later to write about this most challenging and extraordinary artist.

I was initially assisted in my research by Tate's very capable library and archive staff. During the writing of the book in 2014 I was supported by colleagues at Falmouth University, particularly Dawn Lawrence, who helped me source the prolific literature on Freud published during the last decade of his life. This explosion of serious interest and new research – mostly through exhibitions – has further informed the content of this book, which attempts also to consider Freud's legacy.

I would also like to thank Diana Rawstron, Professor Geoff Smith, Virginia Verran, Pat Utermohlen, and my husband Tom Scott for his tireless support. Finally, special thanks go to my editor Alice Chasey, copy editor Colin Grant and picture researcher Sarah Tucker. Their careful handling, diligence and professionalism have been greatly appreciated.

PHOTO CREDITS

INDEX